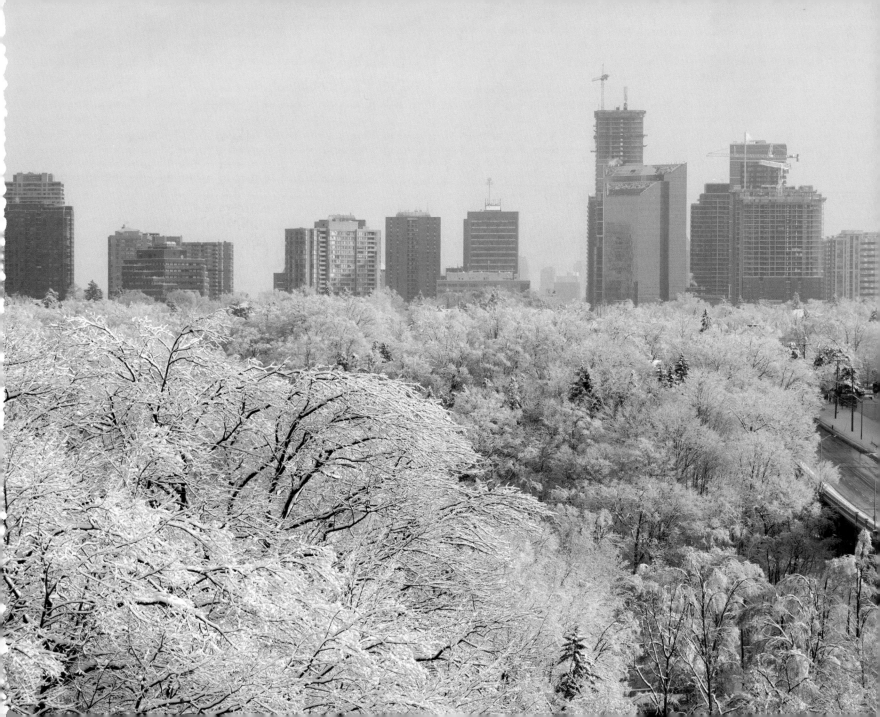

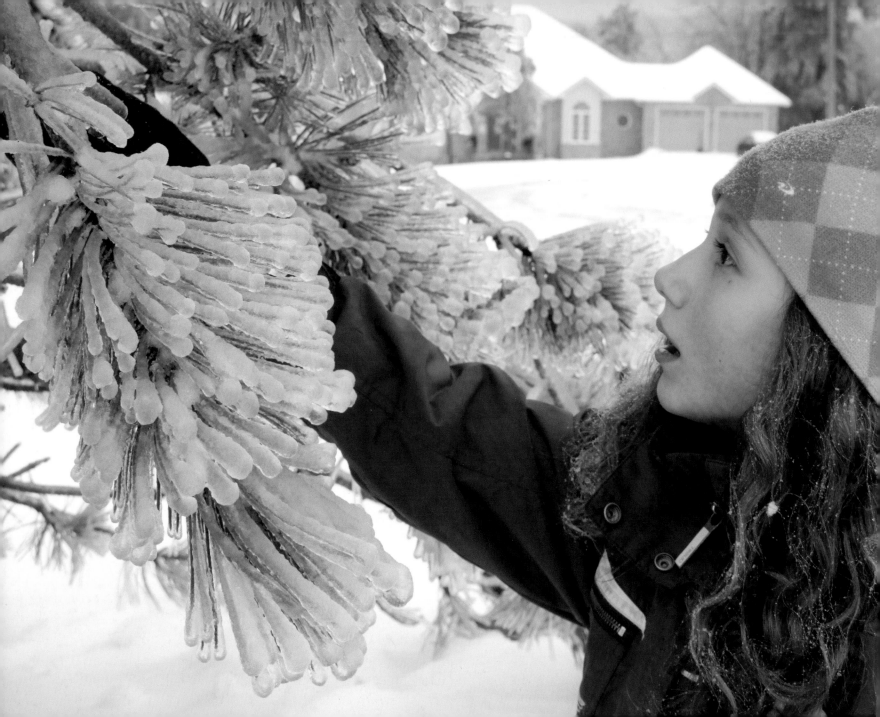

ICE STORM

ONTARIO 2013

THE BEAUTY, THE DEVASTATION, THE AFTERMATH

Toronto Star

Introduction by Michael Cooke

ECW Press

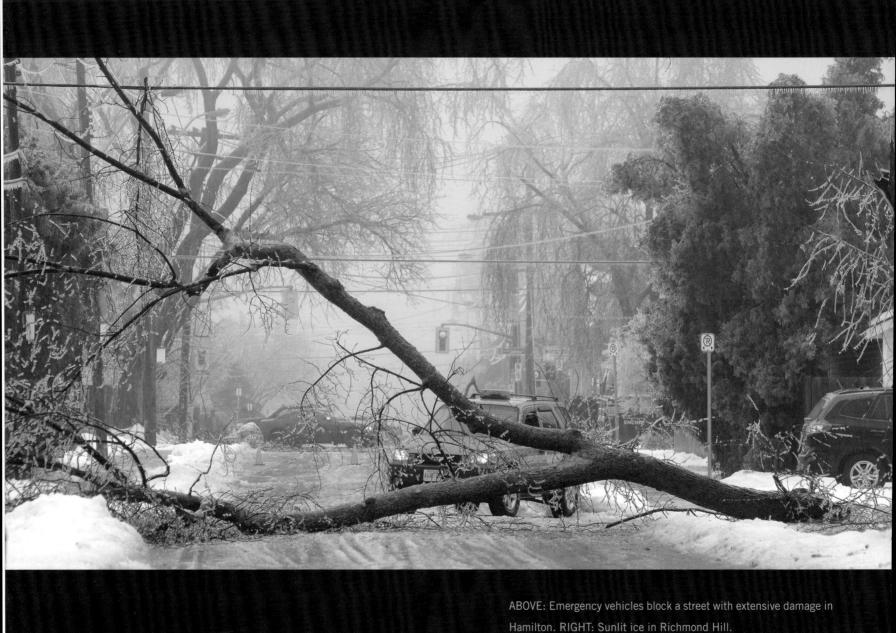

ABOVE: Emergency vehicles block a street with extensive damage in Hamilton. RIGHT: Sunlit ice in Richmond Hill.

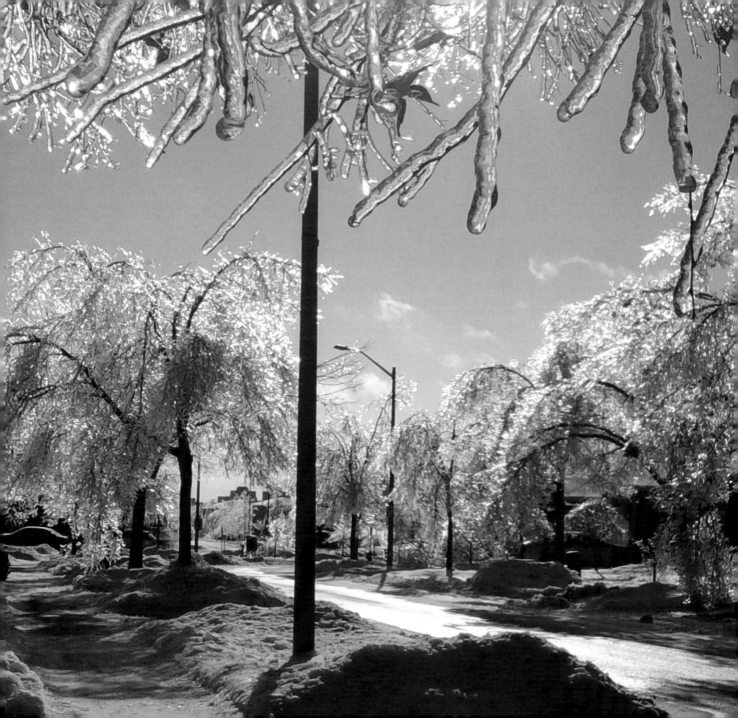

Introduction

Christmas of 2013 was more like 1913 for people in Canada's largest city.

No lights. No heat.

Nearly half a million hydro customers in the greater Toronto area, and many more along the storm's path, were plunged into cold and darkness as the worst ice storm in our history caked over our region and taught us all to appreciate what we take for granted: a click of the switch and the lights come on.

Panic.

Grandma is coming and that turkey needs cooking.

We weren't really transported back to the old days, but sometimes it felt like it as we pulled an extra blanket over our shoulders and cooked outside on coals.

We had problems our pioneer ancestors never faced, such as: where do I plug in my mobile phone?

And, more seriously, thousands of Torontonians who live in highrises struggled with the long climb up countless stairs when elevators stopped working.

But people did what you hope people would do when faced with a weather emergency. They offered help to friends and neighbours and even complete strangers.

Star reporter Joel Eastwood talked to Sheri Hebon and her family who were stuck freezing with their two-year-old twins until Sheri sent up a flare on Facebook. Next thing you know, Sheri, her wife Katarina, their four-year-old son, Nate, along with little Maya and Zev were camping out in a friend's home for the duration.

"In some ways, it just brings out the best," said Sheri.

In the end, it was our trees that got the worst of it. The Star's Christopher Hume posed this question: has disaster ever looked so beautiful?

The trees were frozen in glittering ice as though "they have been decorated just in time for Christmas," wrote Hume.

But, boy, did they take a beating. There are about 10 million trees in and around Toronto and more than a million now face the axe because of ice damage. We'll see this clearly in the summer when there will be big gaps in the green canopy over residential streets.

Mayor Rob Ford said we were enduring "one of the worst storms in Toronto's history," and although the experts never declared a state of emergency, everyone agreed we came *that* close.

As you'll see when you leaf through this book, there are dozens of images that tell our stories of pluck and endurance. One man who embodies those attributes is David Farmer, the last man in the region to get his power back. The headline on a Star story about him read, "One person still doesn't have heat – his name is D-d-d-david."

Farmer kept his house warm from wood he chopped in his big Mississauga yard. "When the machine stops, it's nice to know you can carry on," he said.

That sums it all up.

Michael Cooke

Editor

Toronto Star

RISE AND SHINE

It's time for the world juniors.
Canada kicks off the tourney with an early morning tilt against Germany, **S1**
Follow our live blog starting at 7:30 a.m. at thestar.com

Friday's Jackpot
Lotto **MAX**
$41 MILLION estimated

TORONTO STAR

WEATHER HIGH -1 C | CLOUDY, LIGHT SNOW | **MAP** S10 **THURSDAY**, DECEMBER 26, 2013

The dark side of Christmas

It was a festive time for many. For others struggling with no power, they're 'just trying to survive'

ALEX BALLINGALL
STAFF REPORTER

It didn't feel like Christmas as Vic Baniuk and his wife, Gisela, woke up shivering Wednesday morning.

It was their fourth day in the cold without power.

"For us, there is no Christmas," said Baniuk, 64, who lives with his wife and dog on Catalina Dr. in Scarborough's Guildwood Village.

Normally, their children come down from Barrie to mark the holiday with a big family dinner, but with the lack of heat paralyzing activity in the house — Baniuk said his toothpaste is frozen and his joints have tightened up — the plan for Christmas supper this year was a can of chicken soup, boiled over a gas camping stove.

"My wife is so depressed she took the Christmas tree apart and put it away," he said. "Nobody's coming here. It's just us, and we're just trying to survive."

The Baniuks are among thousands of people in Toronto who are still in the dark after a violent ice storm ravaged the area Saturday night. As power trickles back into blacked-out neighbourhoods, some of those left without electricity are frustrated it hasn't returned. People told the Star Wednesday that they're tired of battling the relentless cold by huddling at warming centres set up by the city, shacking up at local hotels or spending hours on end in restaurants to savour the heat.

For some Torontonians, in short, the blackout ruined Christmas.

"I've had a really rough ride in this disaster, and I've been totally shocked about the level of unpreparedness for the people that are supposed to be handling this," said Baniuk. "You look at all the trees and all that's left are these bent-up sticks . . . It looks like you're in a war-torn country."

Baniuk added that he hasn't seen any Toronto Hydro trucks in his neighbourhood, and that he's had trouble getting in touch with anybody from the municipal government.

STORM continued on A4

Normally, Vic and Gisela Baniuk have a big family Christmas dinner at their Scarborough home. This year, they froze by candlelight with a can of soup.

RANDY RISLING/TORONTO STAR

THE ICE STORM

Hearty meal
Scott Mission's annual dinner connects those in need. "It's like family here," **GT1**

Xmas work
Bell-ringers, ice cleaners, ER doctors. Not everyone gets the day off, **GT1**

Online
For updates, videos and reader photos, visit thestar.com/icestorm

Residents ask, 'How is this not an emergency?'

MARCO CHOWN OVED
STAFF REPORTER

It was a cold, dark Christmas for tens of thousands of people in Toronto who spent the holiday without power and heat more than four days after a crippling storm coated the city in ice.

While hundreds of thousands of residents were reconnected in the first few days, an estimated 72,000 households were still in the dark on Christmas Day and could have a long wait ahead of them, stoking fears that the 1,000 people who sought refuge in city warming centres on Christmas Eve would grow more numerous in the days to come.

While temperatures remain frigid, Mayor Rob Ford said he would not call a state of emergency because he did not want to panic anyone in the city.

"This is not a state of emergency," he told a press conference at city hall on Christmas morning alongside the chiefs of city services.

"We're not even close."

Hydro crews continue to work around the clock, assisted by additional personnel from as far away as Manitoba.

POWER continued on A6

>READY, SET, SHOP
Is the ice storm going to keep Boxing Day shoppers away? Store owners hope not, **A3**
We have a 20-page section inside with all kinds of deals. And if that's not enough, just flip through our first three sections.
SALE

Canada turns up heat on Russia's anti-gay laws

'Concerned' Baird sends letter to 'encourage' Putin to uphold human rights for all citizens

LES WHITTINGTON
OTTAWA BUREAU

OTTAWA—Canada wants Russia to end discrimination against gays — both during the Sochi Winter Olympics and afterwards.

In a letter obtained by the Star, Foreign Affairs Minister John Baird urges Russian President Vladimir Putin's government to act in the "Olympic spirit" of tolerance and uphold human rights for Russians — as well as foreign visitors — regardless of sexual orientation.

"In the lead-up to Sochi, Canada remains concerned about the legislation passed in June 2013 that places a ban on the 'propaganda' of non-traditional sexual relations among minors," Baird says in the Dec. 11 letter to Russian Foreign Minister Sergey Lavrov.

Baird says the International Olympic Committee and the Canadian Olympic Committee have received assurances from Moscow that the anti-gay law enacted in June will not affect those taking part in the Sochi Games.

But, Baird adds, "we encourage the Russian Federation to extend to all citizens — as well as foreign visitors — full human rights protections, including freedom from violence, harassment or discrimination based on sexual orientation."

RIGHTS continued on A2

Foreign Affairs Minister John Baird has urged Russia to loosen its rules.

9

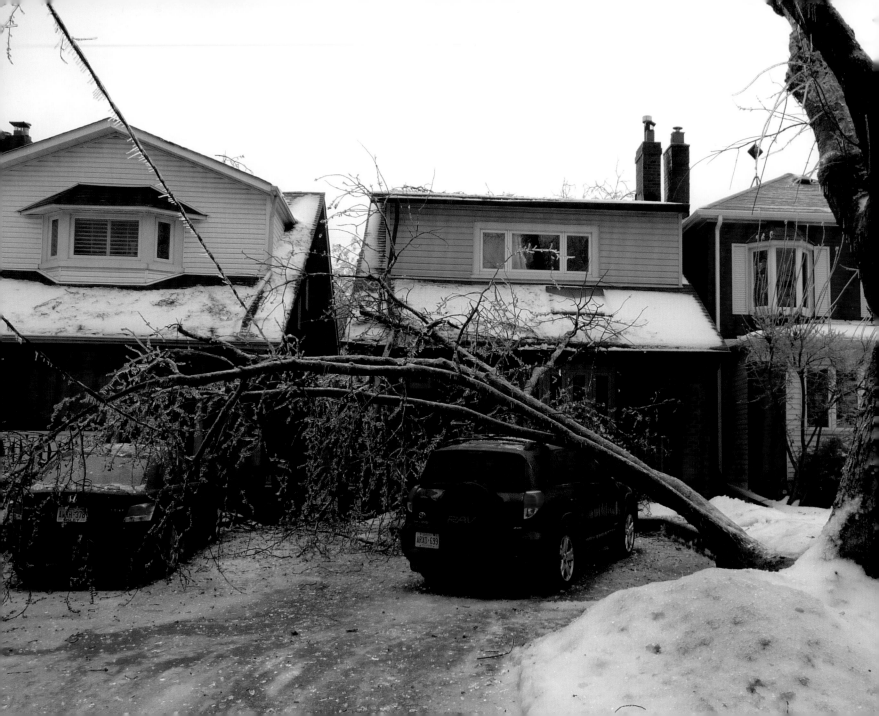

KILLER WEATHER

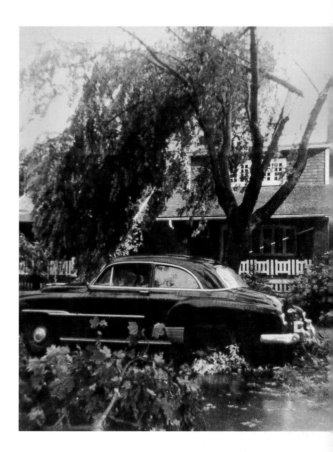

Southern Ontario is not known for extreme weather. So on those occasions when nature does decide to vent its fury on Canada's most densely populated region, the shock is all the greater. As is the destruction. In October of 1954, Hurricane Hazel laid waste to Haiti and parts of the United States before racing north to tear into Toronto and the surrounding areas, killing 81 people and doing hundreds of millions of dollars in damage. In 1999, a week-long blizzard buried Toronto in hip-deep snow – a potential disaster in a metropolis of over two-and-a-half million people. (Then mayor Mel Lastman famously called in the army for support.) And in the summer of 2013, the city was drenched by record rainfall that flooded homes, turned roadways into car-swallowing lakes, knocked out power for thousands, and lifted an entire commuter train off its tracks, stranding its passengers. The ice storm that hit much of eastern Canada just before Christmas in 2013 was something else entirely. Unlike those other weather disasters, this one crept in with barely a sound, silently encasing whole neighbour-hoods in frozen rain that glittered and shone in sun, even as it wreaked havoc and left a million people without power – some for weeks. This book chronicles that storm, in all its cold, destructive beauty.

The ice storm and Hurricane Hazel struck the same tree on Briar Hill Avenue. LEFT: December 2013. RIGHT: October 1954.

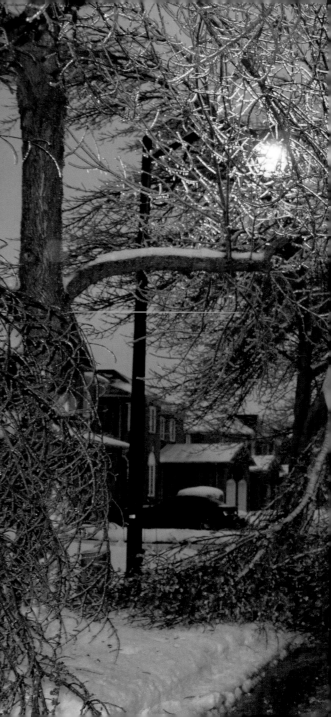

Early morning on December 22 in Markham, as the freezing rain continues to fall.

PART 1

THE STORM

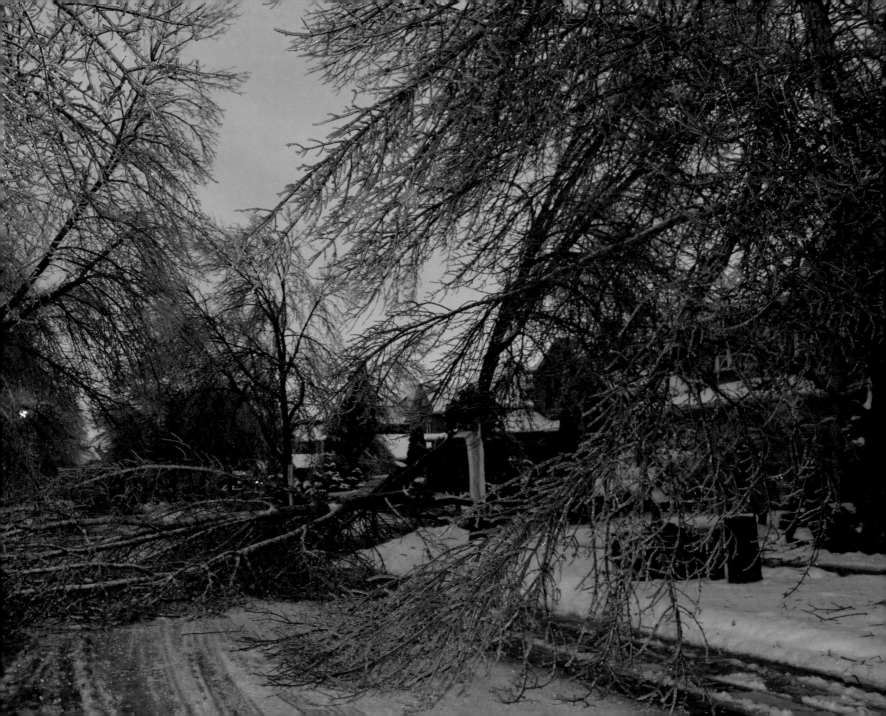

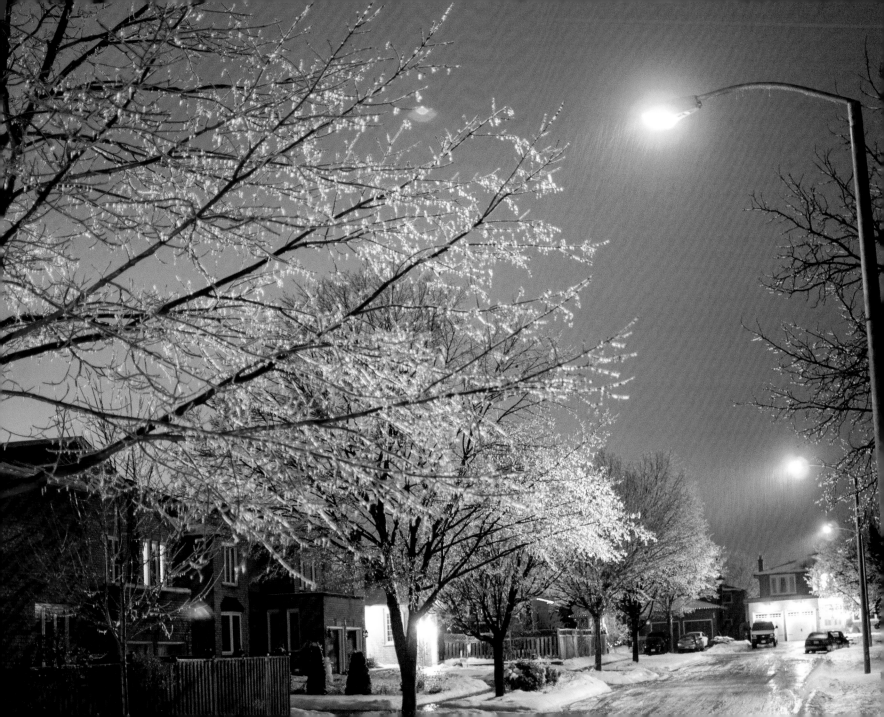

On Friday, December 20, a massive warm front extending all the way from Texas began to creep across Southern Ontario. The front, which had created spring-like conditions south of the border, ran smack into a stubborn, slow-moving system of cold, Canadian air. Whenever two strong fronts meet, weather chaos is inevitable. Heavy snow fell by the bucketful at the margins of the system, but along its turbulent southern edge, what came out the sky was a dark curtain of freezing rain, hundreds of kilometers long. Over the weekend, the storm moved east across the shores of Lake Erie and Lake Ontario, and then through southern Quebec, following the St. Lawrence River until it hit the Maritime provinces. The rain that drenched cities and towns froze solid as it landed, hardening into a mass tens of millimeters thick that brought down branches and trees and snarled traffic. High winds followed, making things worse. In Toronto, all streetcar routes were shut down, as were some subway lines. Streets became slick and dangerous. On the highways, cars slid into ditches and each other. Power went out all over the region, as generating stations failed and the falling trees brought lines down. At the height of the holiday travelling season, airports were forced to cancel flights, stranding thousands of passengers trying to get home or get away. Before the storm had even blown itself out, debates raged online and in the media over its relative magnitude – was it worse than the '98 storm that crippled Montreal and parts of eastern Ontario? Should we call in the army? But one thing was indisputable: it made a hell of a mess.

LEFT: The freezing rain that fell on December 21 and 22 stuck to whatever it came into contact with – trees, homes, streets, cars – and immediately formed a clear layer of ice more than two-and-a-half centimetres thick in places. In all, the hardest-hit areas got around 30 millimetres of rain, but it was more than enough to turn the entire region into a slippery disaster zone. Mike Smith captured the beginning of the storm in Scarborough late on December 20. RIGHT: In Scarborough, a streetlight is the victim of a falling branch.

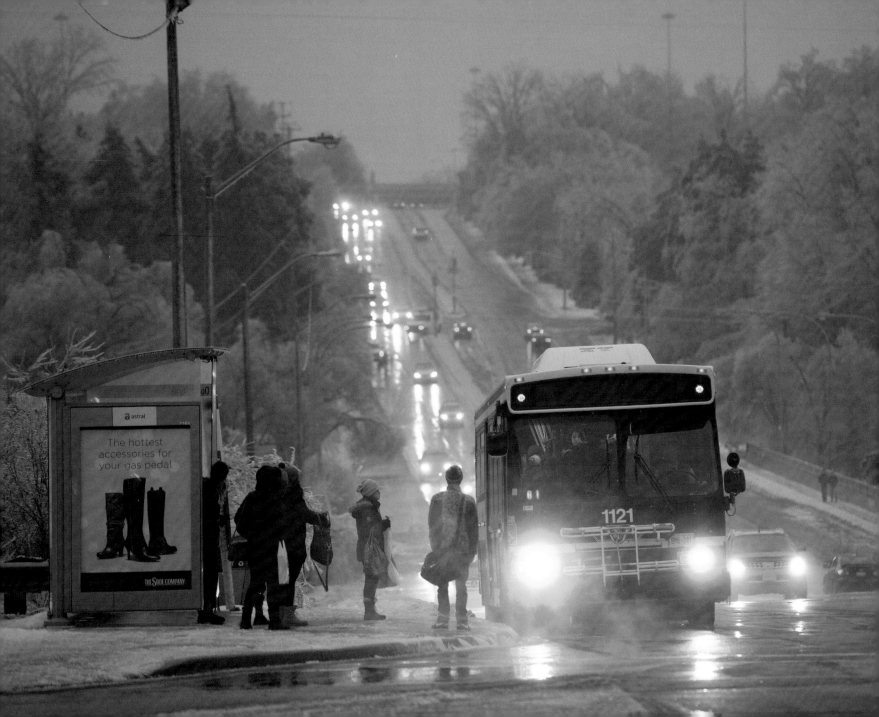

1121

LEFT: Passengers board a TTC bus on Don Mills Road. Parts of Toronto's transit system were shut down by the storm. Behind them, the area of homes and apartment buildings lies in darkness.

ABOVE: A Toronto bus shelter on Yonge Street, looking like a tiny ice castle.

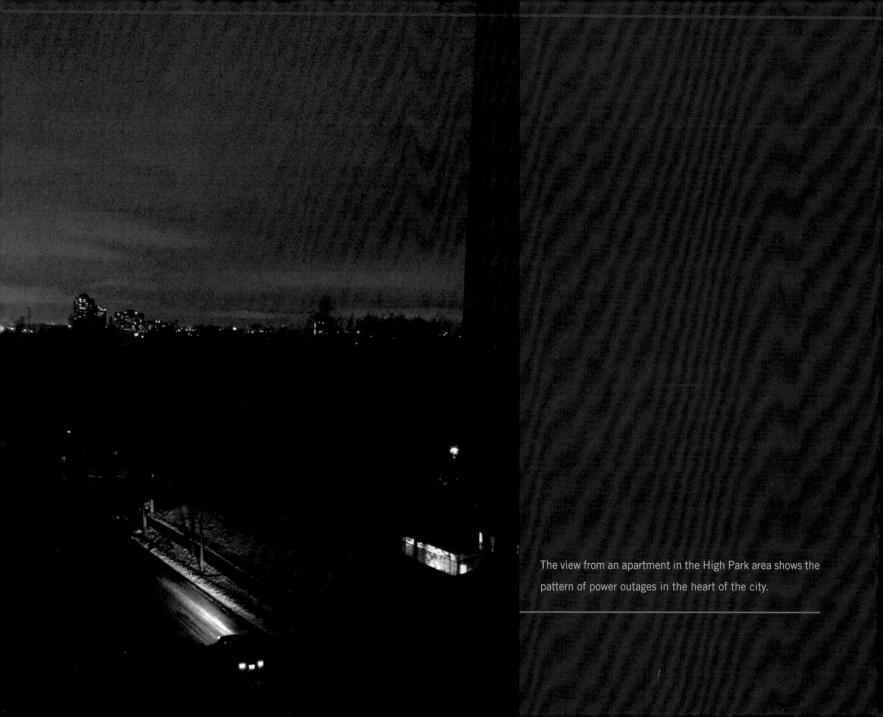

The view from an apartment in the High Park area shows the pattern of power outages in the heart of the city.

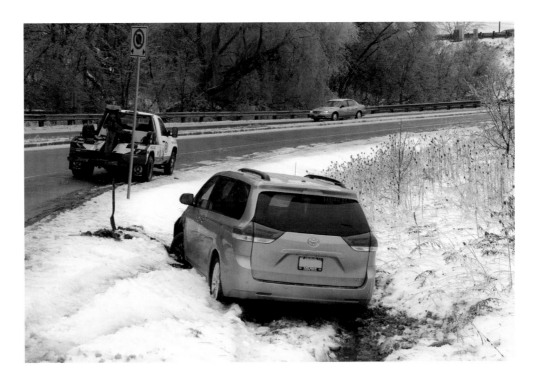

LEFT: Leslie Street is closed after falling branches bring down dangerous live wires. ABOVE: Cars slid off the road all over the GTA as the freezing rain left behind treacherous black ice. There were few fatalities from highway accidents across the region and the toll was not nearly what it might have been, since many heeded the warnings to stay off the roads.

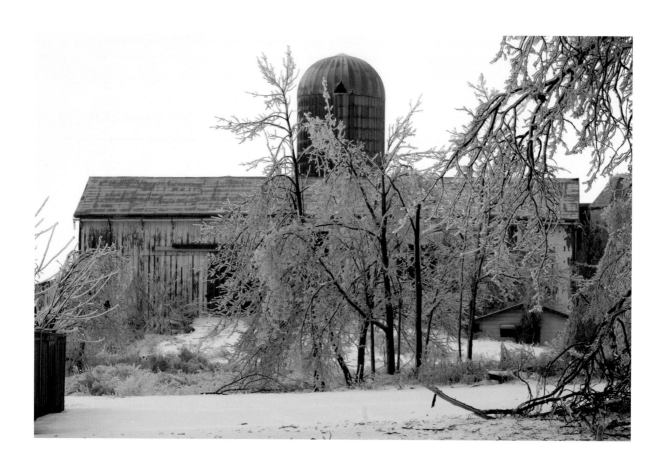

ABOVE: A frigid Georgetown farm. RIGHT: Throughout most of southern Ontario, people awoke on the morning after the storm to a world transformed. Overnight, the landscape looked as though it had been painted with a thick, frozen lacquer. Scenes like the one opposite, on First Line between Milton and Guelph, were almost apocalyptic in their grey stillness.

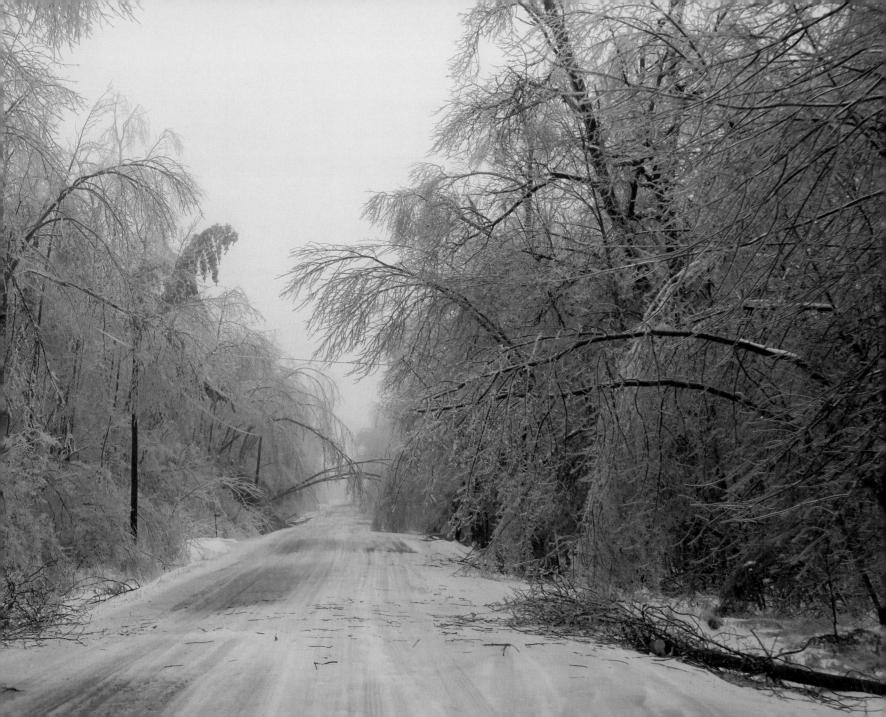

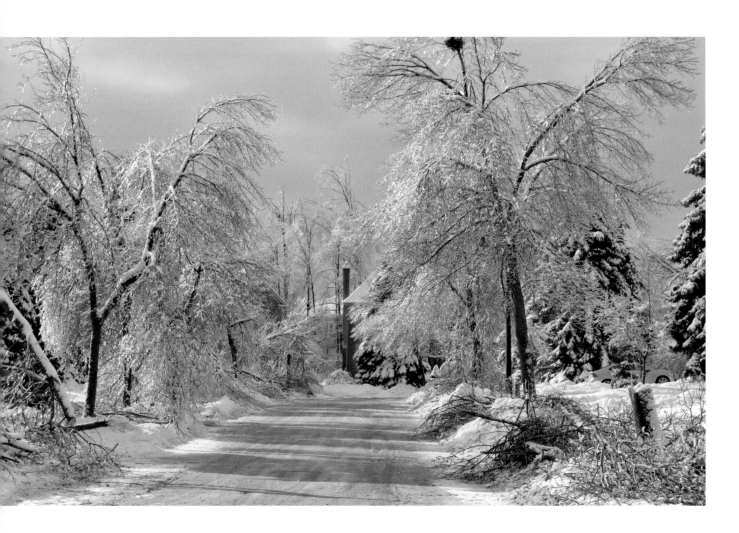

ABOVE: A quiet street in Richmond Hill is nearly unrecognizable beneath the ice and snow. RIGHT: Sunset in Richmond Hill.

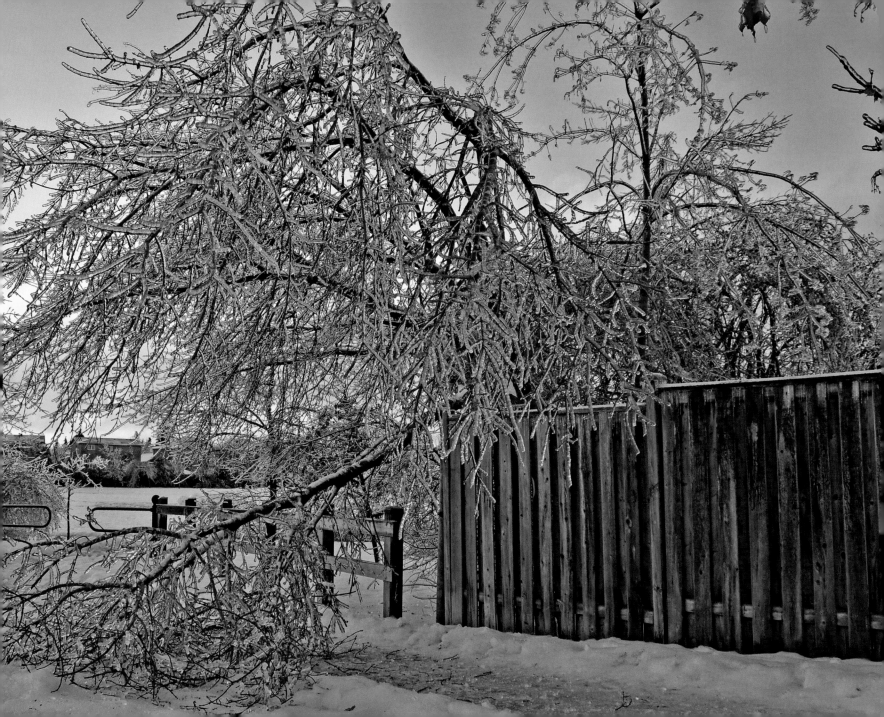

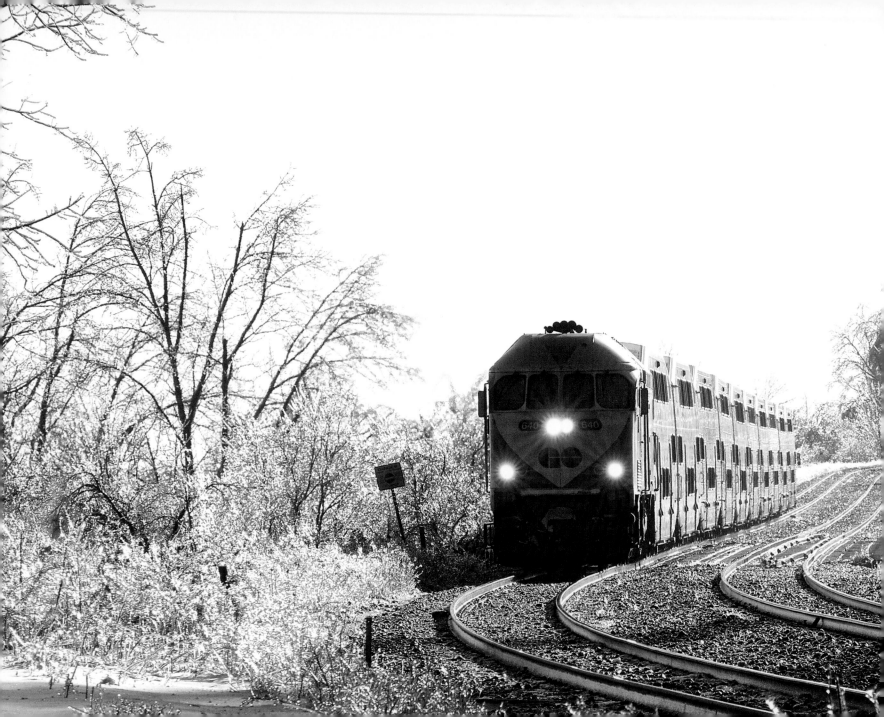

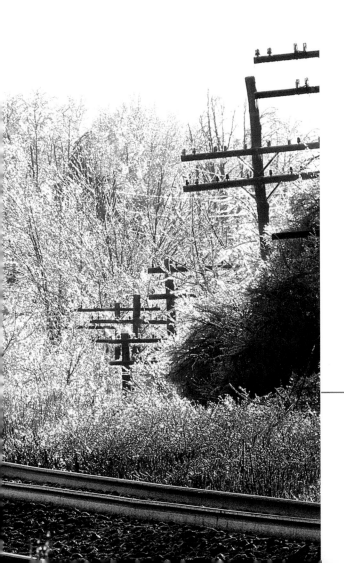

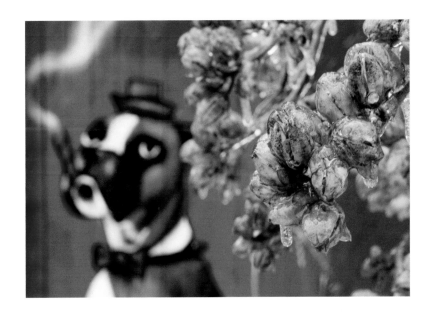

LEFT: A GO train crosses the Rouge River, looking like something out of a children's picture book. ABOVE: In Kensington Market, Rose of Sharon seed pods droop with ice while a painted bulldog shows its displeasure.

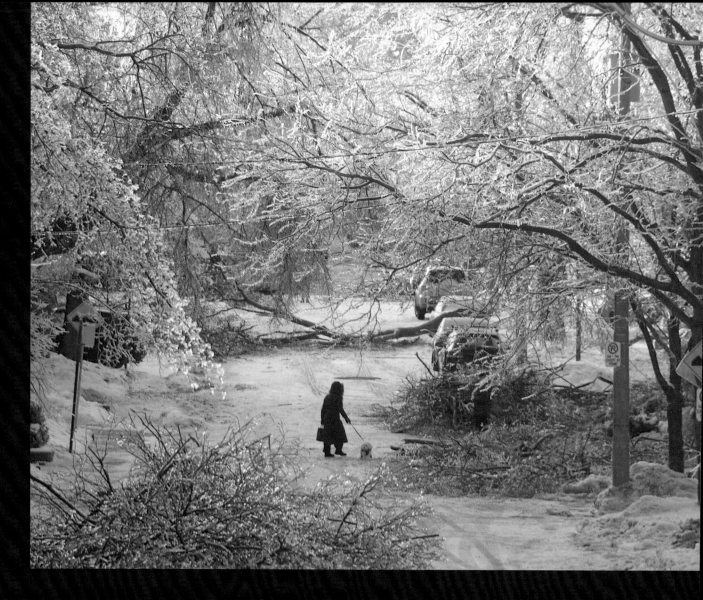

Despite the danger from downed power lines and trees, many people across Ontario had no choice but to venture outside – to get groceries, to run errands, or to begin the arduous task of cleaning up the mess left behind. Here, a lone woman walks her dog amid the destruction in Toronto's Briar Hill neighbourhood.

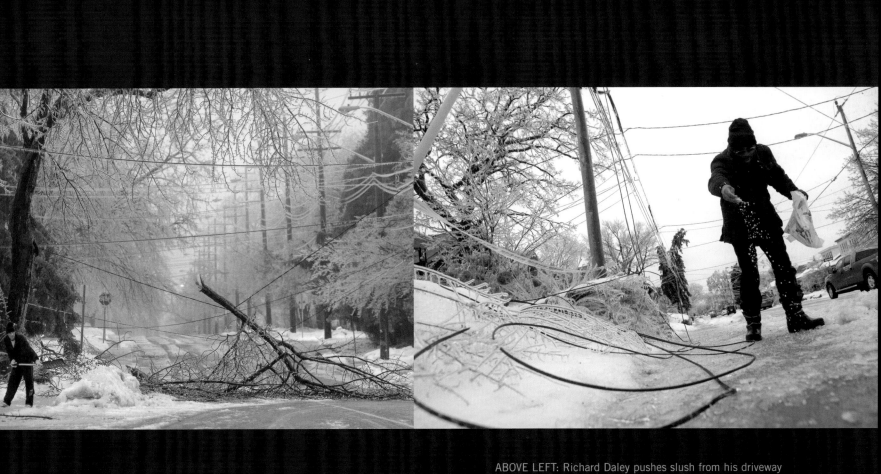

ABOVE LEFT: Richard Daley pushes slush from his driveway in Hamilton. ABOVE RIGHT: An East York resident carefully salts his sidewalk, inches from a downed line.

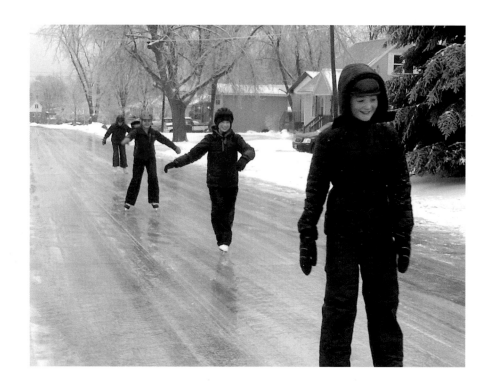

ABOVE: In Kingston, the freezing rain left the streets as smooth as if a Zamboni had passed by. Here, four children take advantage of the conditions and skate down the middle of the street.

RIGHT: In Toronto's north end, a jogger braves the cold and a dangerous new obstacle course.

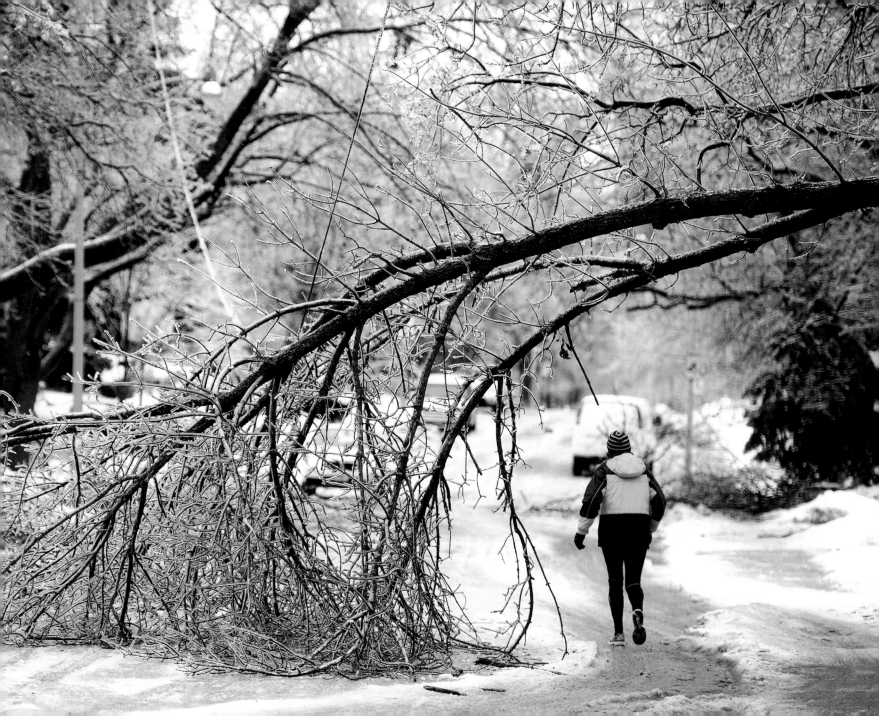

RIGHT: A pair of young Torontonians document the storm's icy aftermath. FAR RIGHT: Most Ontarians expected the ice to disappear once the sun returned, as often happens following a bout of freezing rain. Instead, the temperatures dropped and the wind picked up, hardening the ice and shaking burdened trees past the breaking point. The sight of shattered tree limbs quickly became an alarmingly familiar one. Here, an old Norway maple has demolished a car in Riverdale.

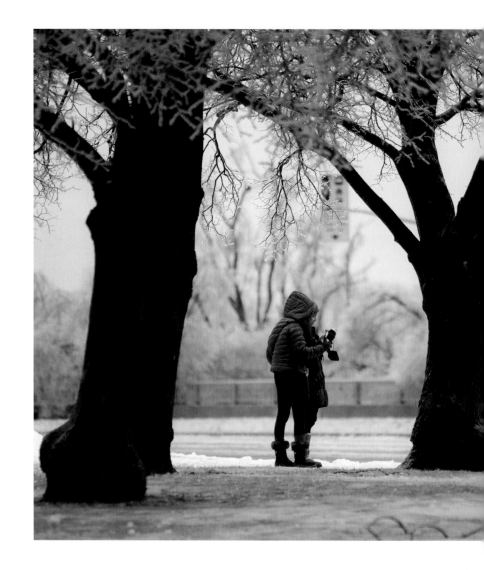

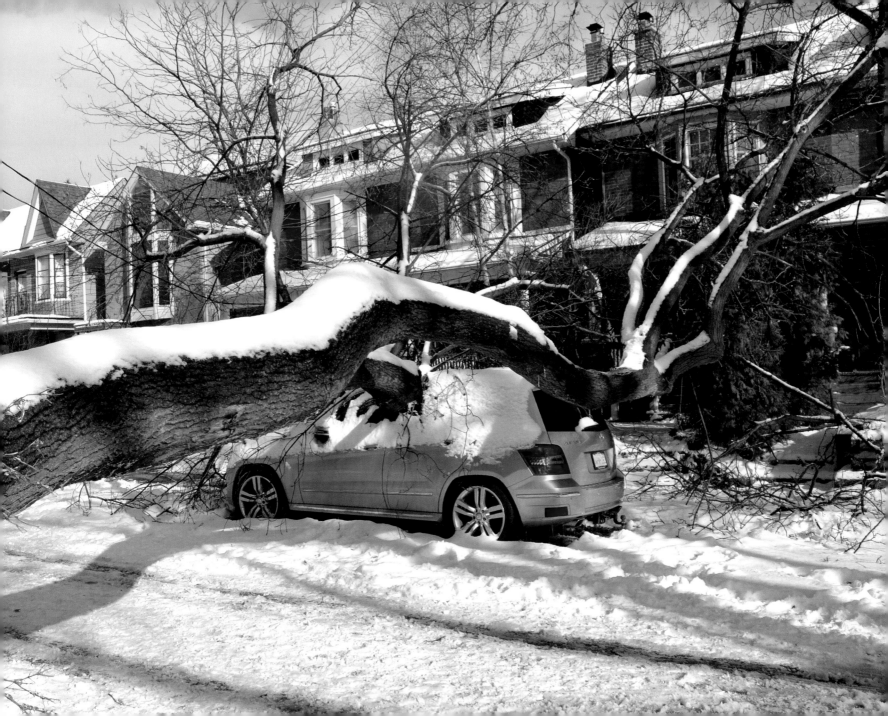

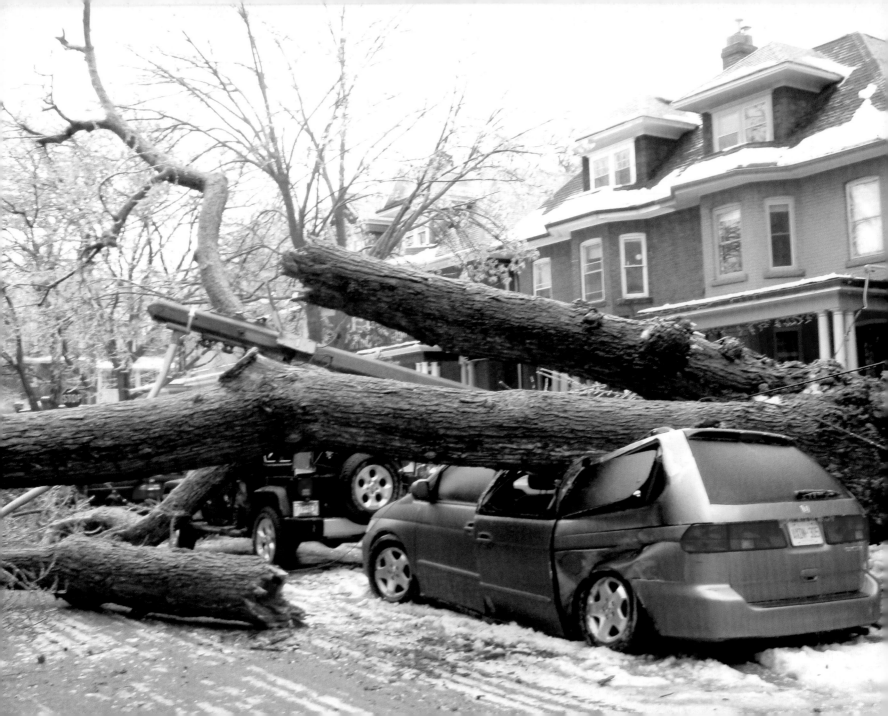

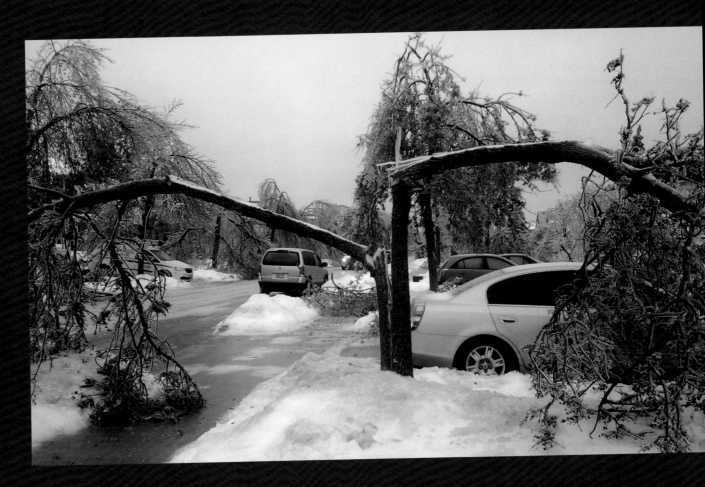

LEFT: On Kendal Avenue in Toronto's Annex neighbourhood, a 100-year-old maple was toppled by the weight of the ice, bringing down a utility pole and crushing a Jeep and a minivan. ABOVE: A tree in Brampton split in half, as if by a giant axe.

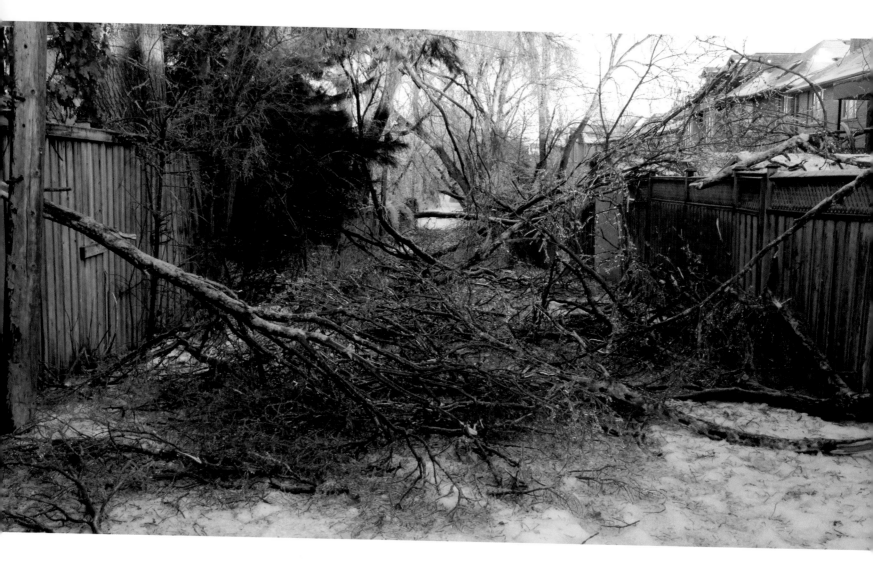

A North York alleyway is a dense thicket of downed branches.

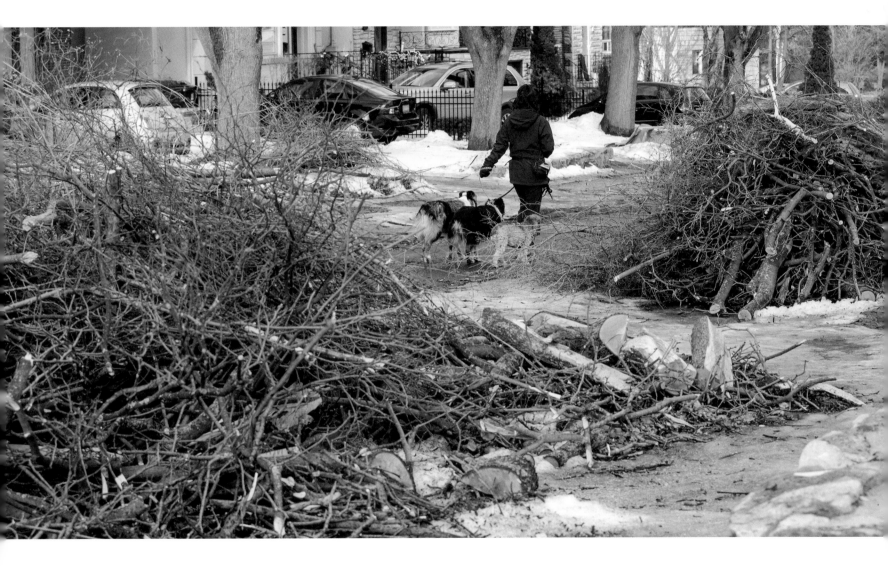

Toronto's Leaside Drive, reduced to one lane by piles of tree limbs.

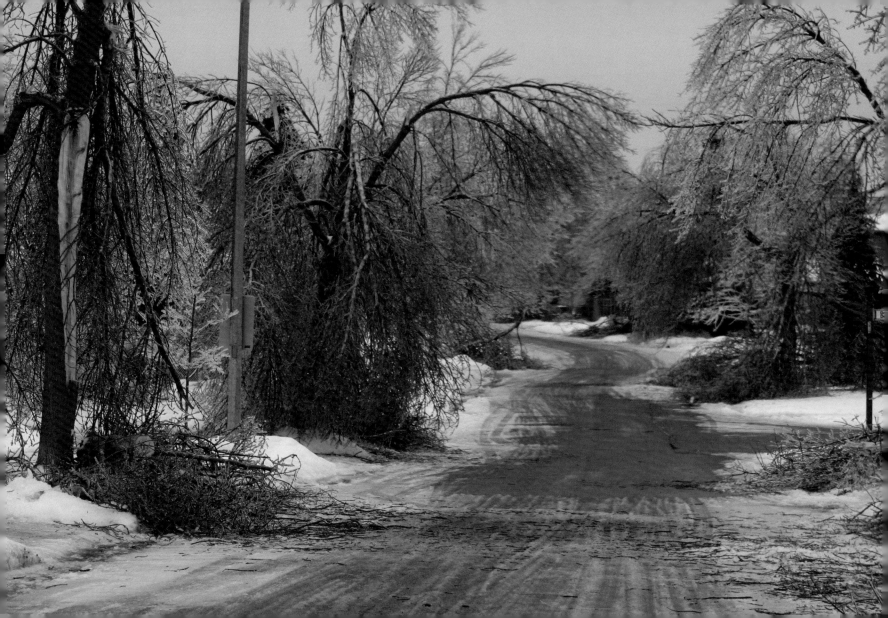

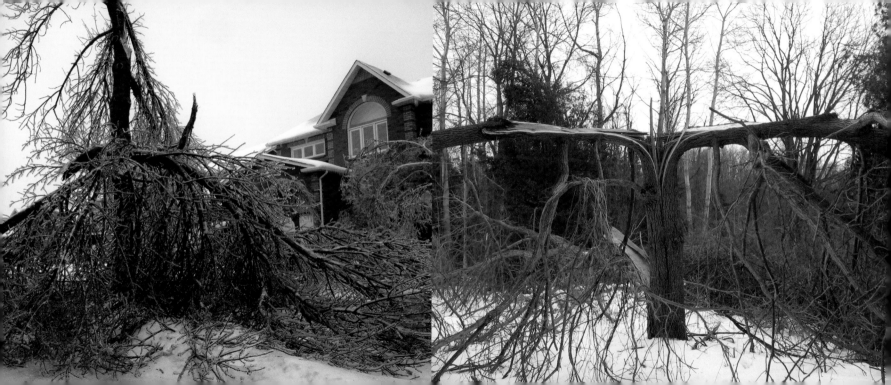

Sunlight refracted by ice creates a scene
of sheer beauty in Oshawa.

PART 2

DEVASTATING
BEAUTY

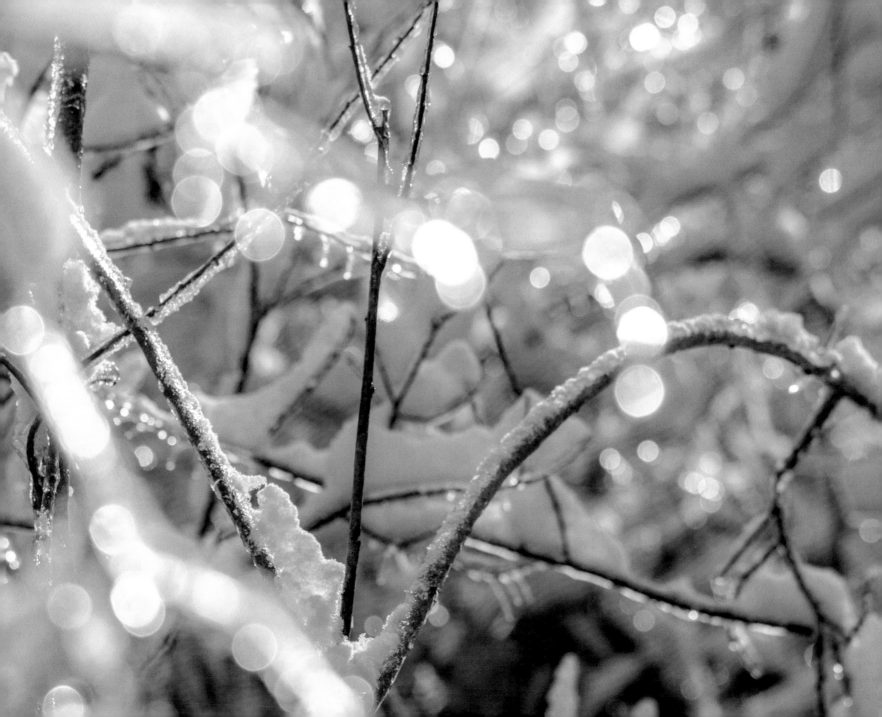

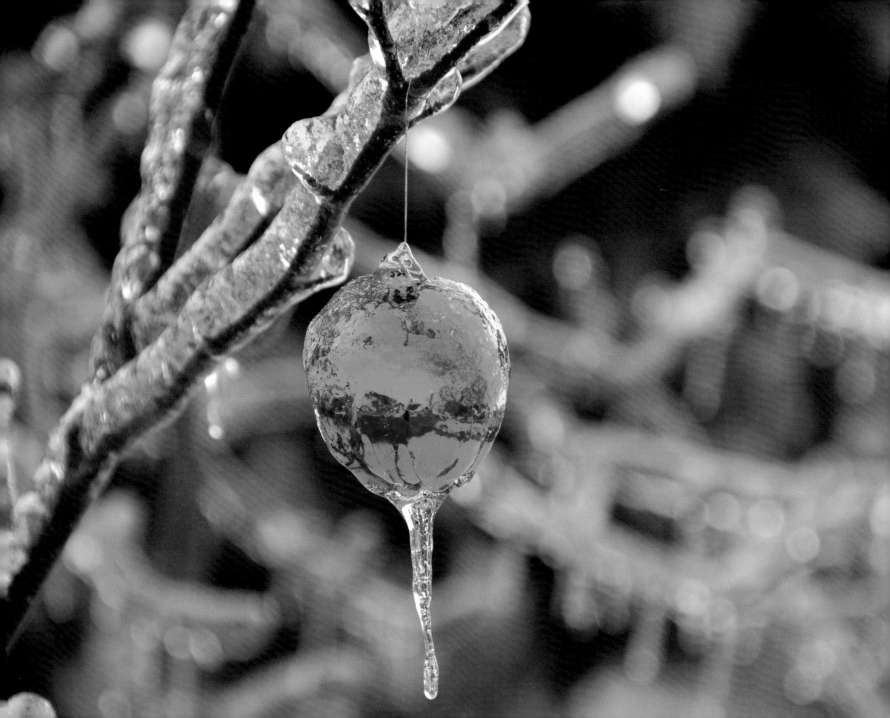

Super-cooled rain that hits the ground and freezes creates what is known as glaze ice. Even the thinnest layer of glaze ice can be a pain for drivers and pedestrians. When it grows thicker than half a centimetre, it becomes a real threat to trees, infrastructure and even airplanes. That danger does come with one unexpected reward: accretions of glaze ice create scenes of startling and often eerie beauty. And where there is beauty, there will inevitably be an army of photographers heading out to capture it. The proliferation of smart phones, digital cameras, photo-sharing sites and social media over the past decade means that any event or experience – no matter how private – can now be shared with millions of people around the world. When the event is something as devastating and widespread as an ice storm, the result is a flood of haunting images that are instantly accessible even to citizens of countries where the idea of freezing rain seems unreal. More importantly, perhaps, the images become a way for those living through the disaster to feel a kinship with people in another city, or on the next block. The photos collected here are only a fraction of the amazing images that could be seen everywhere in the aftermath of the storm – whether in newspapers or on television, or posted on Twitter, Facebook and Instagram. What they all say is this: when ice is everywhere you look, looking at ice can be a revelation.

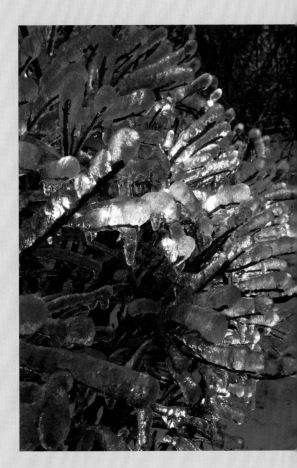

LEFT: A Christmas ball in Markham, at the mercy of the elements. All over the GTA, residents' festive decorations were made even more beautiful by a thick coating of ice.
RIGHT: Christmas lights glow through the ice on a bush in Maple.

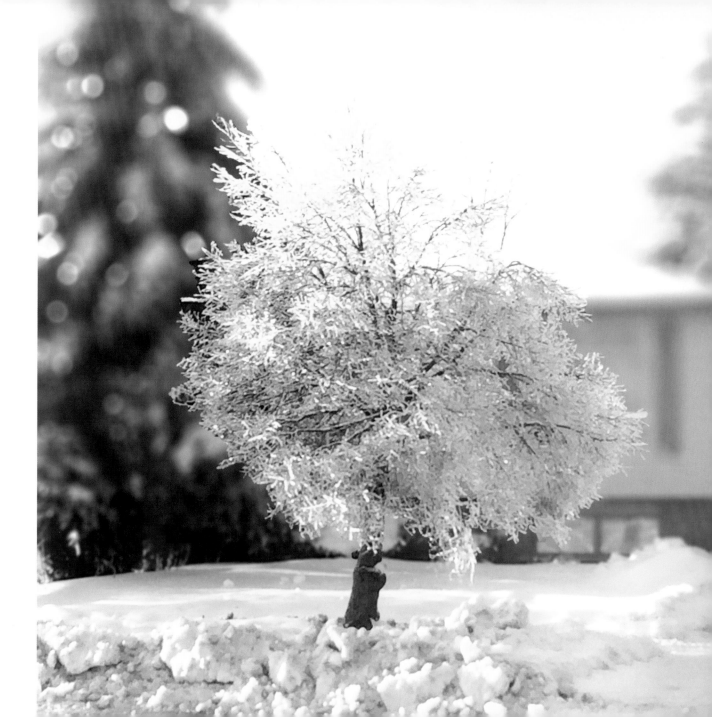

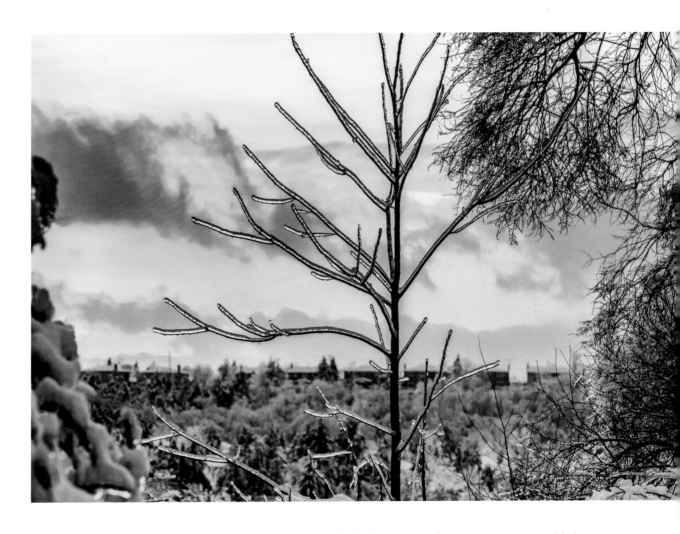

LEFT: There are many stories associated with the storm, but aesthetically there is really only one: trees covered in ice. It was entirely possible to find instances of quirky beauty without a branch in sight, but when it came to photos, cold arboreal glitter reigned supreme. ABOVE: The ice glaze on a young tree picks up the light of a Bolton sunset.

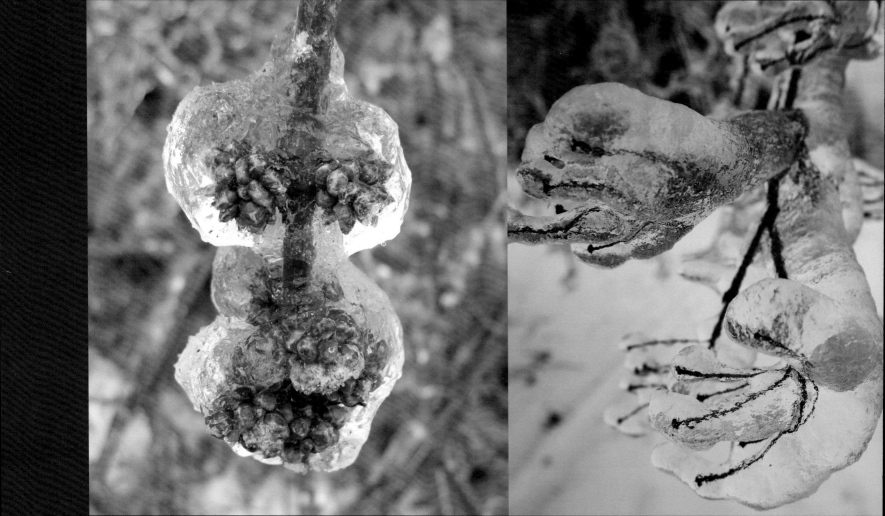

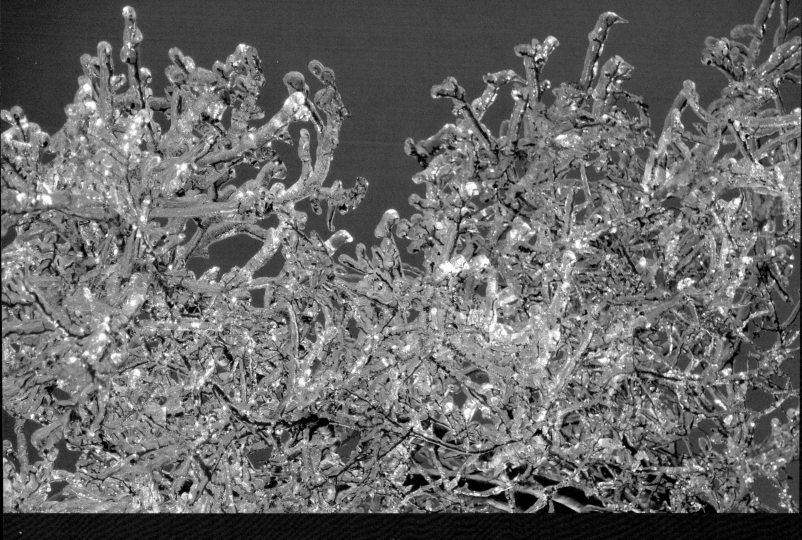

The sheer thickness of the ice accretion turned bushes and shrubs into strange, alien flora.

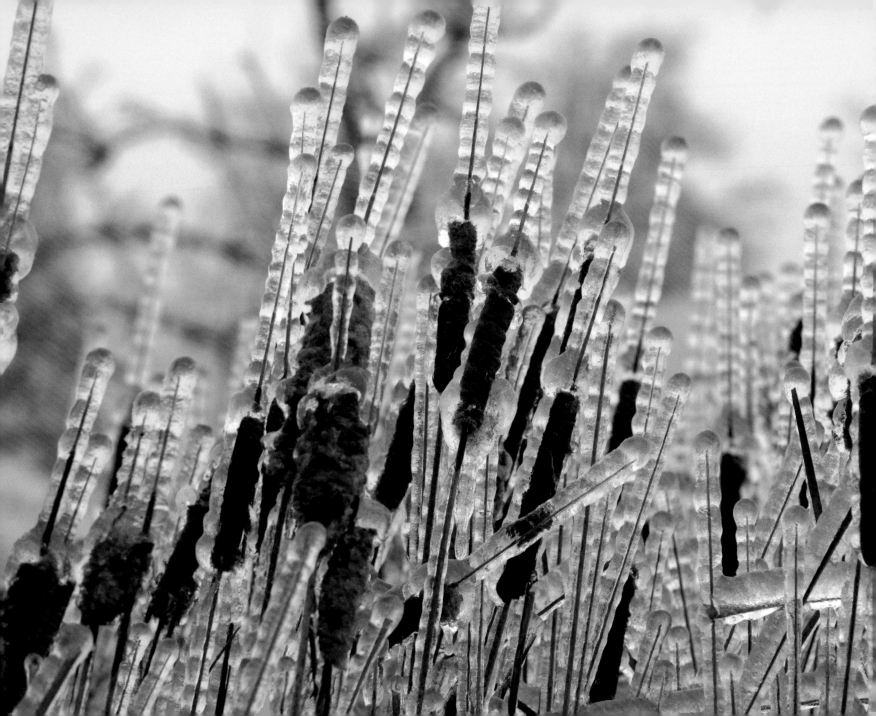

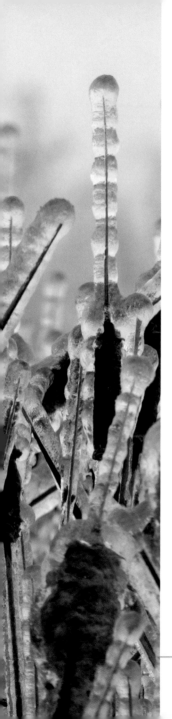

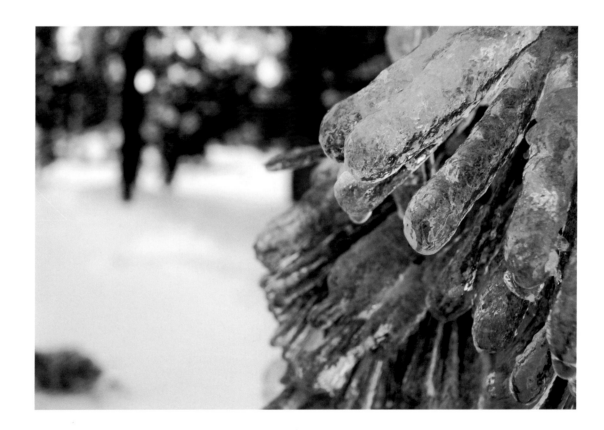

LEFT: Bullrushes near Georgetown display tall, frozen
crowns. ABOVE: June Gleed, a grade 11 student from
Aurora, captured this ice-laden pine branch.

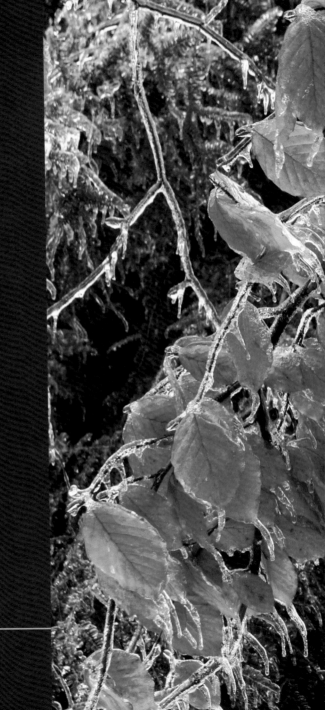

Fall leaves in Port Union, holding on despite everything.

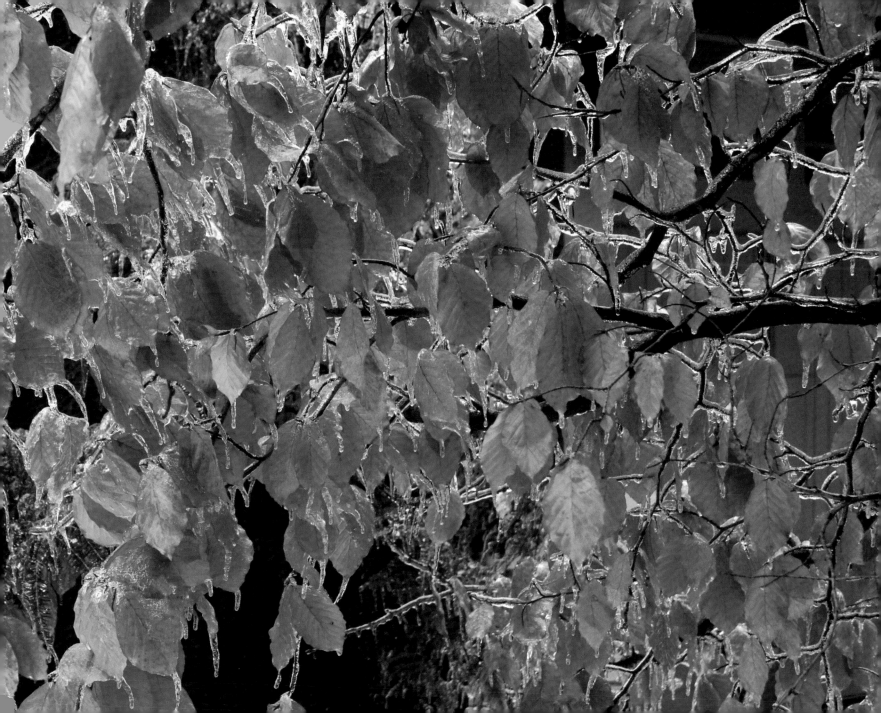

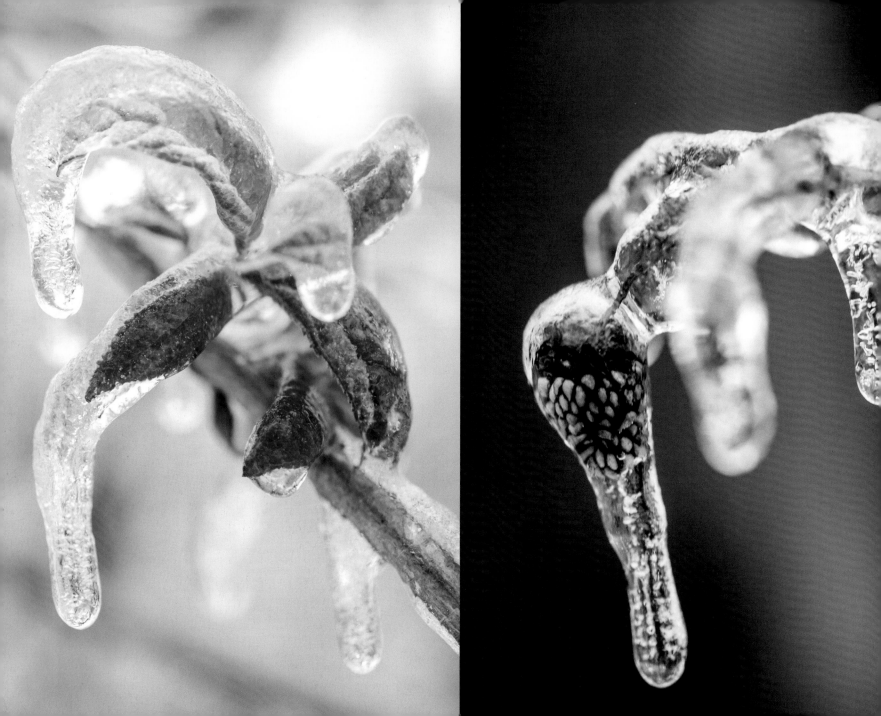

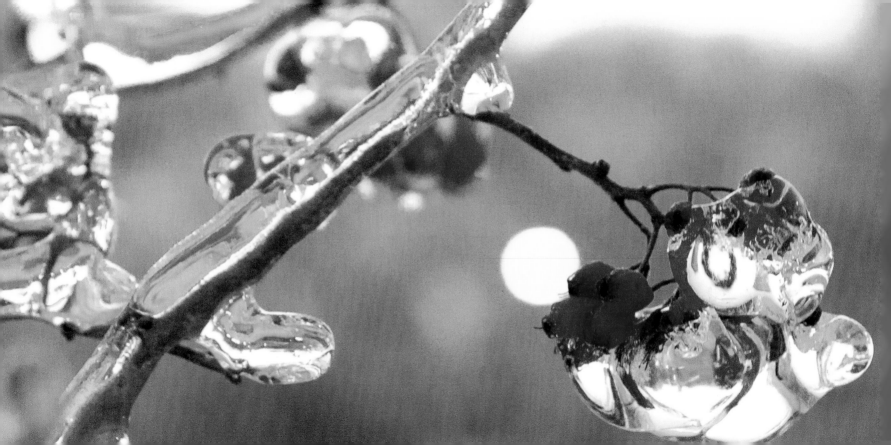

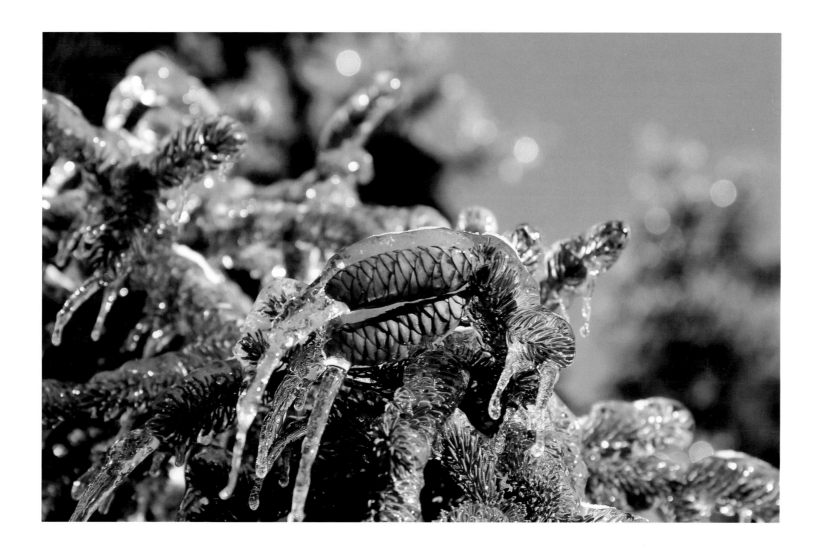

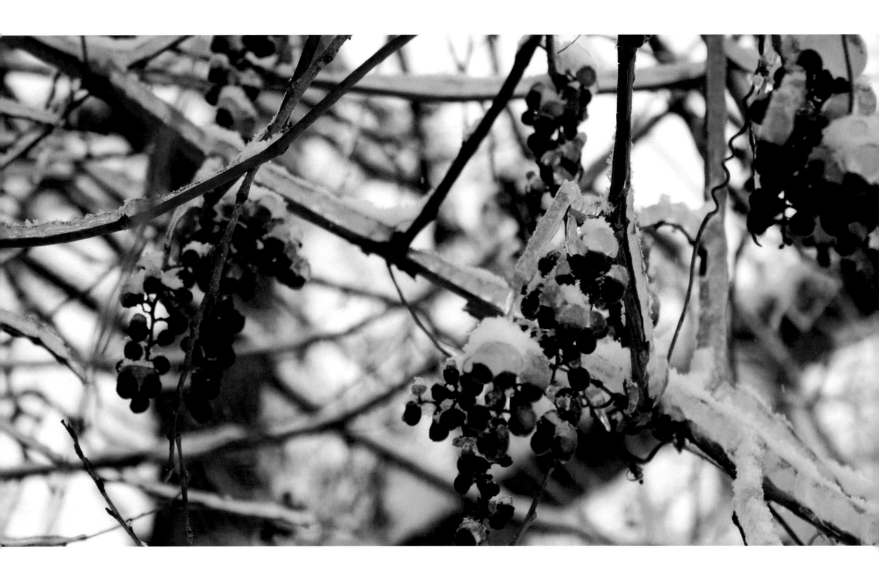

Last year's grapes languish in a vineyard near Picton.

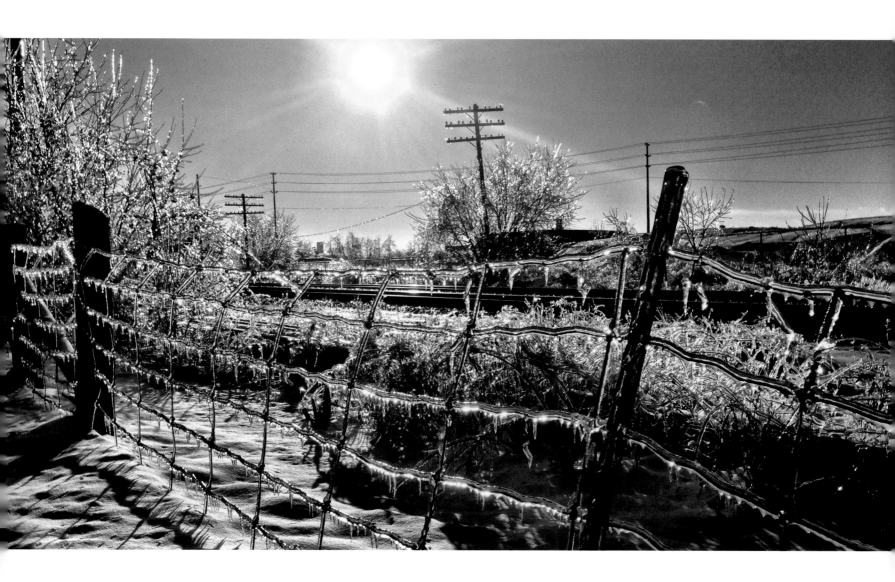

The sun throws every frozen shape into sharp relief in a rail corridor in Leaside's industrial zone.

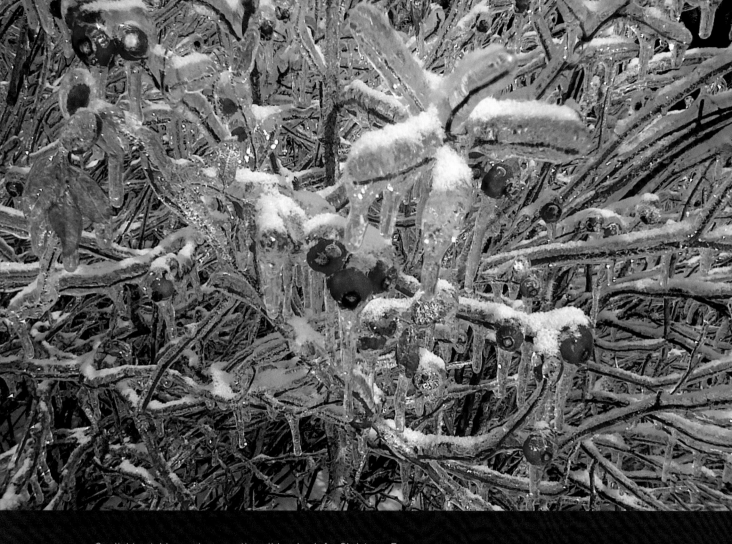

Sunlight catching on ice accretion gilds a bush for Christmas Eve.

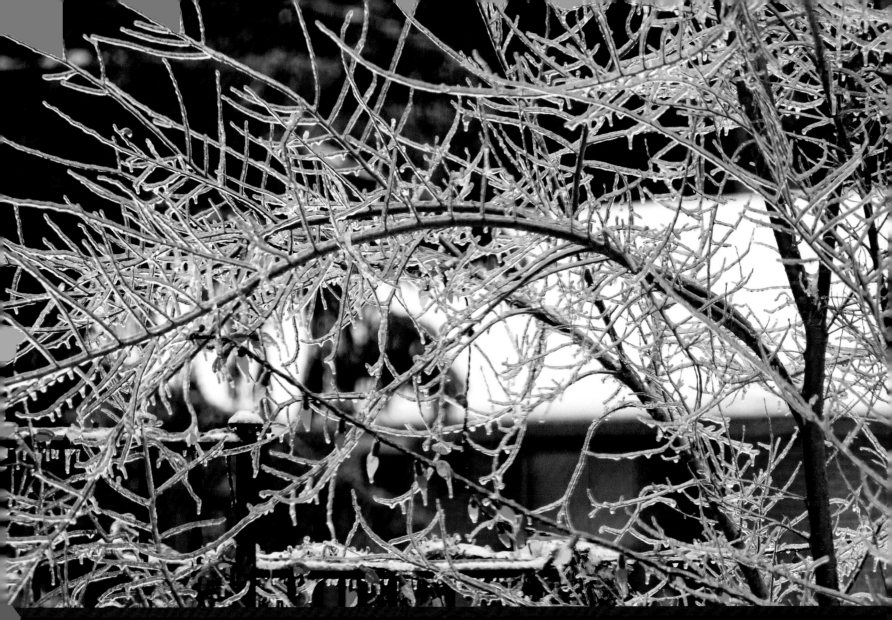

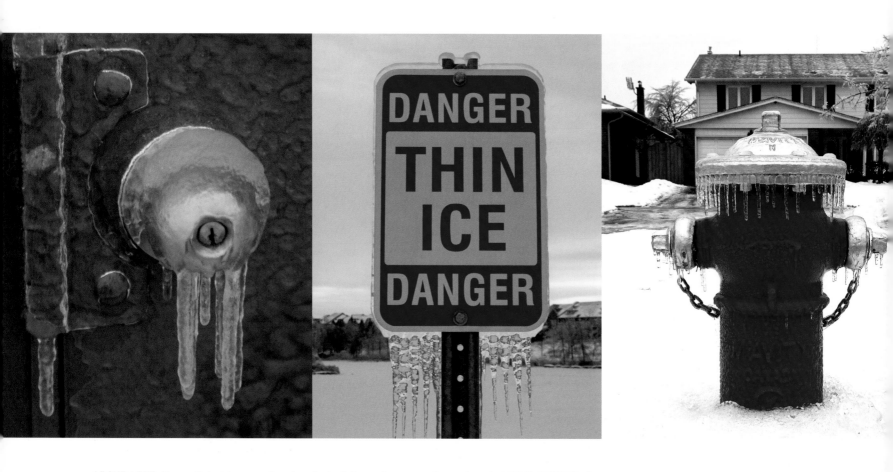

ABOVE LEFT: It wasn't just trees: a door handle in Acton gets an unwelcome beard. ABOVE CENTRE: An unintentionally ironic warning sign in Markham. ABOVE RIGHT: Freezing rain turned even the humblest objects, like this hydrant in Mississauga, into chilly works of art.

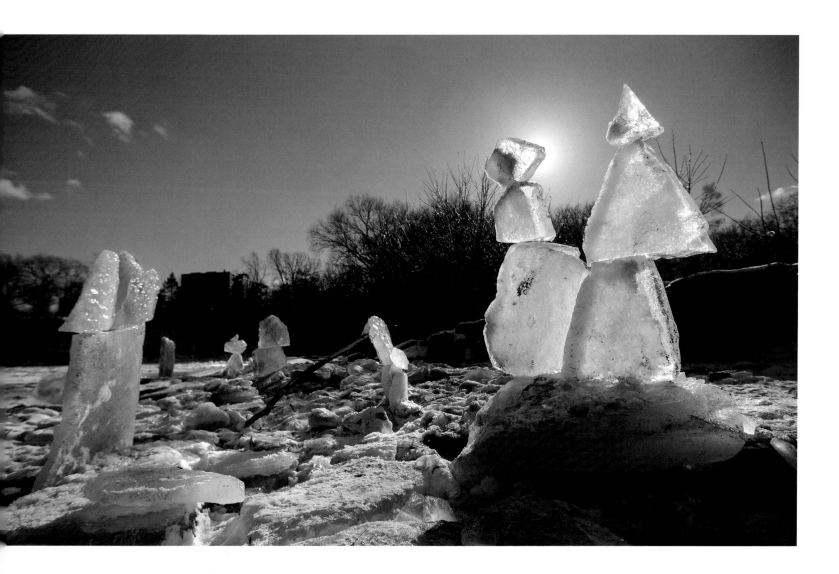

Ice sculptures, looking eerily like people, sit on the shore of the Humber River.

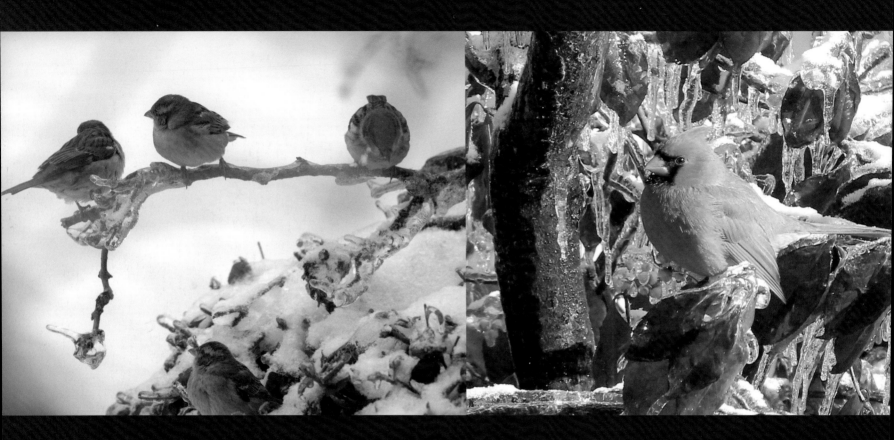

The mess of broken branches and fallen trees meant the loss of homes for many birds, but most feathered creatures treated the newly icy world like it was no big deal. Some, like this goldfinch (LEFT OPPOSITE) in Scarborough, even found a use for the tiny icicles hanging from every twig: instant water fountain.

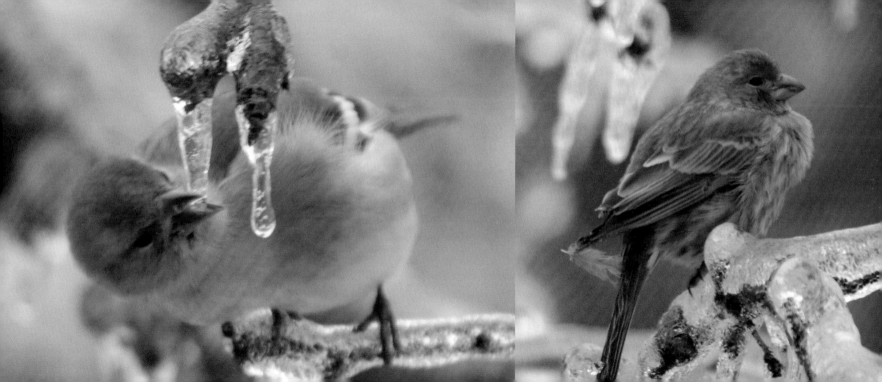

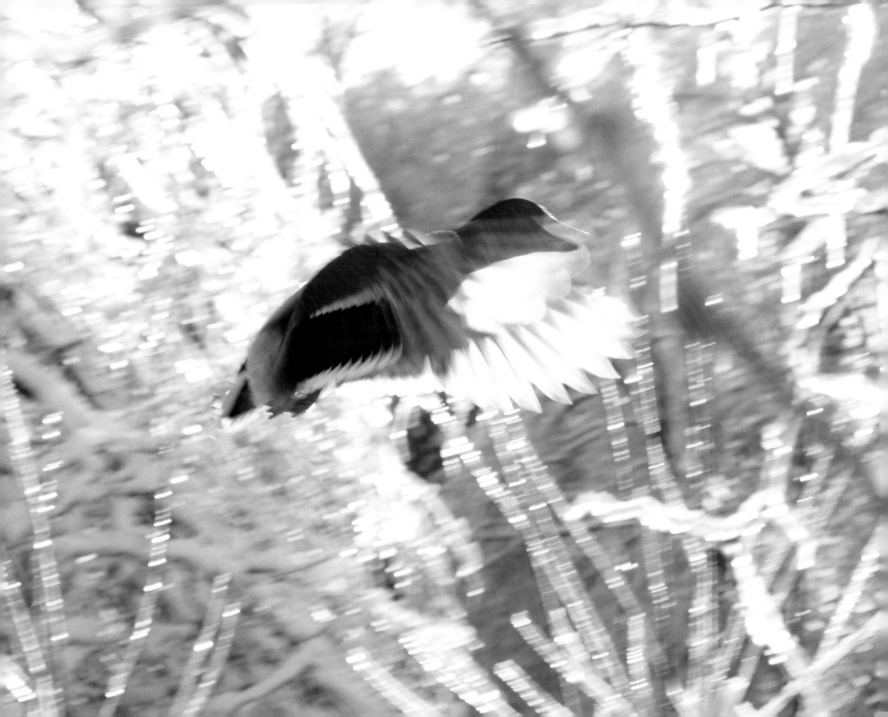

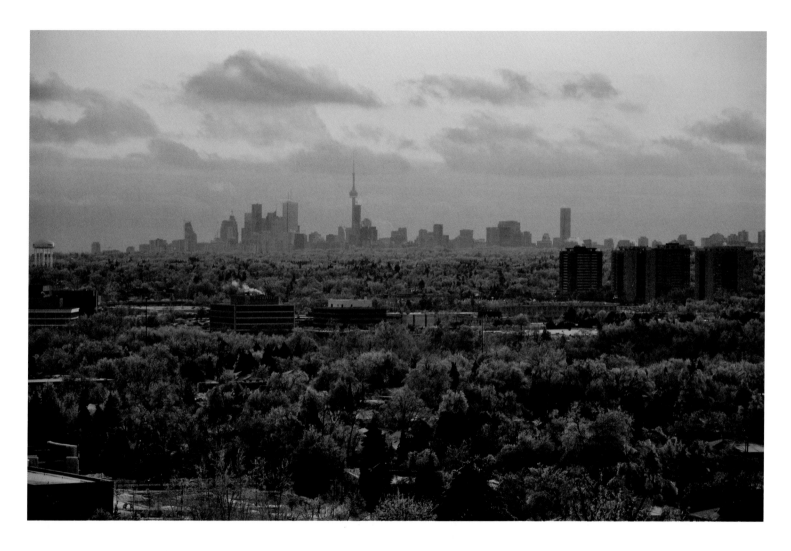

LEFT: A duck takes flight from Mill Pond in Richmond Hill as icy rushes gleam in the background.

ABOVE: Toronto's downtown core looms in the distance over a foreground of ice-covered trees.

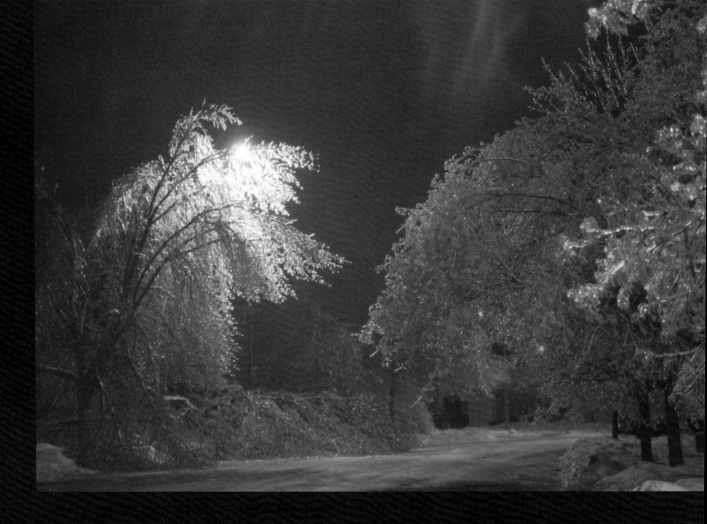

ABOVE: Even as the rain sheeted down, there was a terrible beauty to the
storm. RIGHT: Sunset at the Scarborough Bluffs several days later.

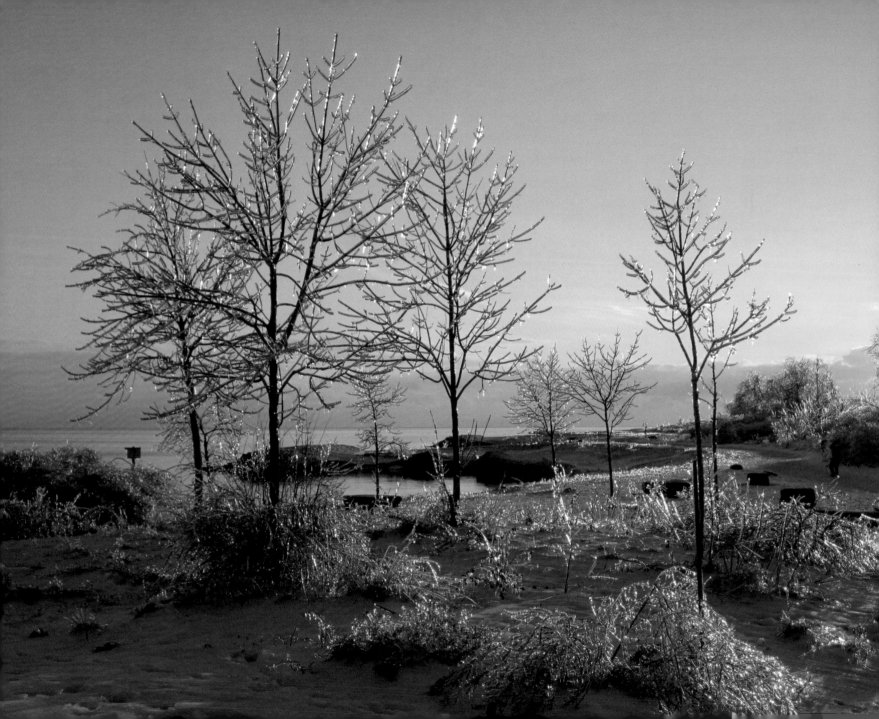

A hydro crew from Manitoba helps clean up Scarborough streets. They arrived on Christmas Eve and worked all through Christmas week.

PART 3

PULLING TOGETHER

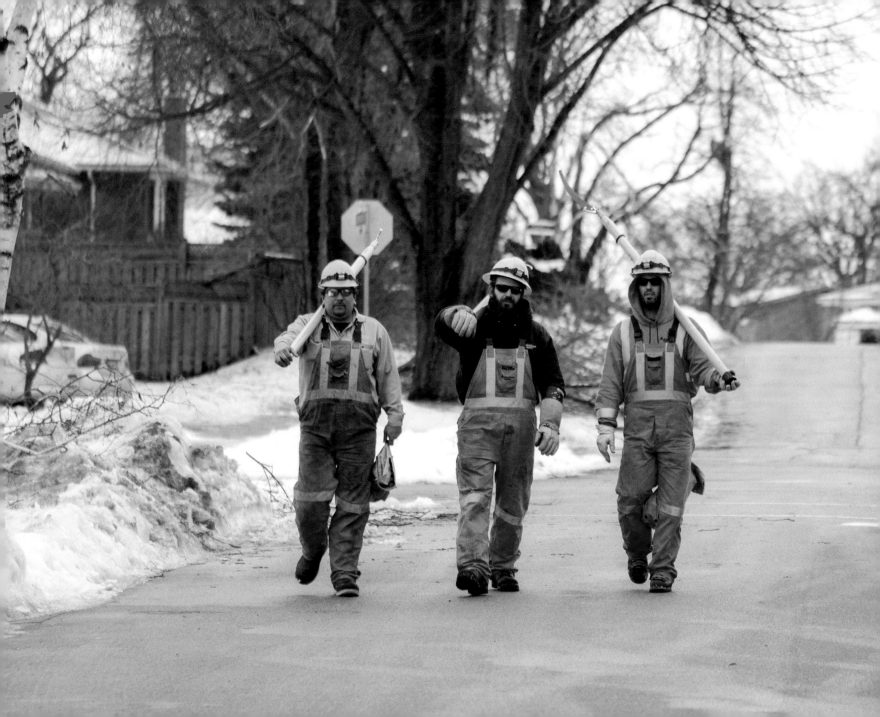

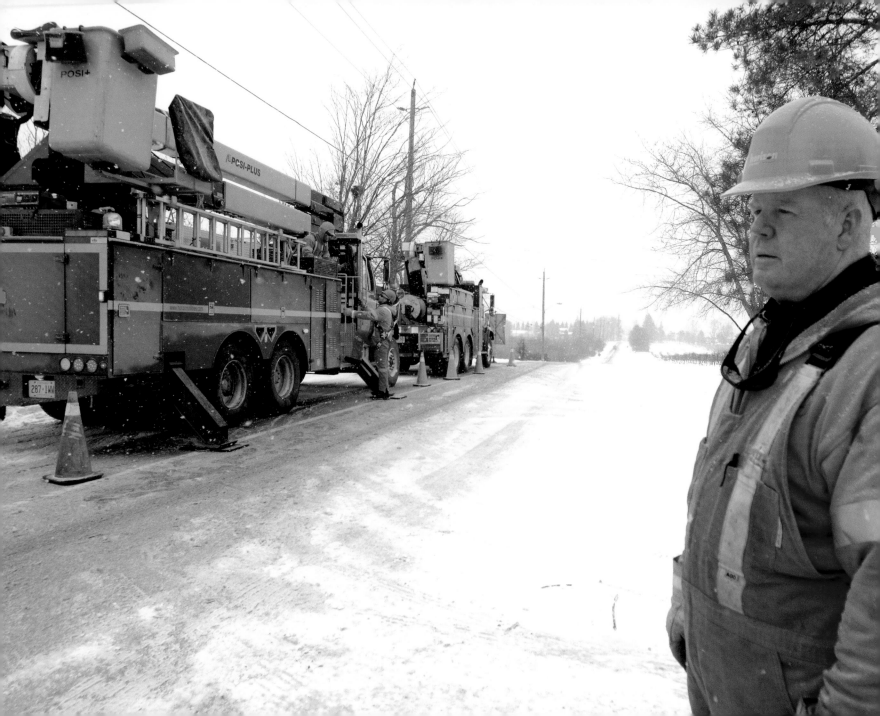

By Monday, people living in the storm's path discovered that although the rain had stopped, the worst part had just begun. They were under siege. At its peak, the resulting power outages left 300,000 households in the dark in Toronto alone. The lights went out for people across southern Ontario, Quebec, New Brunswick, Nova Scotia and parts of the northeast United States. Temperatures dropped and the winds came, making the clean-up and the restoration of power even more difficult. For some, the lights did not go back on until well after the New Year. Those without friends or family members to stay with spent the holidays huddled around candles in their chilly, dark homes, checked into hotels or crowded into warming centres with other people displaced by the blackout. At least two people died in Ontario from carbon monoxide poisoning caused by exhaust from a generator; three more died in Quebec from the same cause. That the power came back at all is entirely due to the efforts of heroic hydro crews, who went street by street and house by house, replacing power lines that had been left scattered on the ground and tangled in broken tree limbs. It was a dangerous, difficult and back-breaking task. Many came from as far away as Manitoba and Michigan, and they worked right through the holidays in frigid temperatures, far from their own homes and families. The hydro workers were a living symbol of the ways many people reacted to the storm's devastation: by bundling up and helping out wherever they could. And even, wherever possible, trying to enjoy it a little.

LEFT: On Christmas Day, lead hand Bruce Robinson and his crew of hydro workers try to restore power along the Fifth Line in Stoney Creek. RIGHT: Across the GTA, people woke up to a thick layer of ice that needed to be hacked and scraped from cars and sidewalks and anything else that needed to be used.

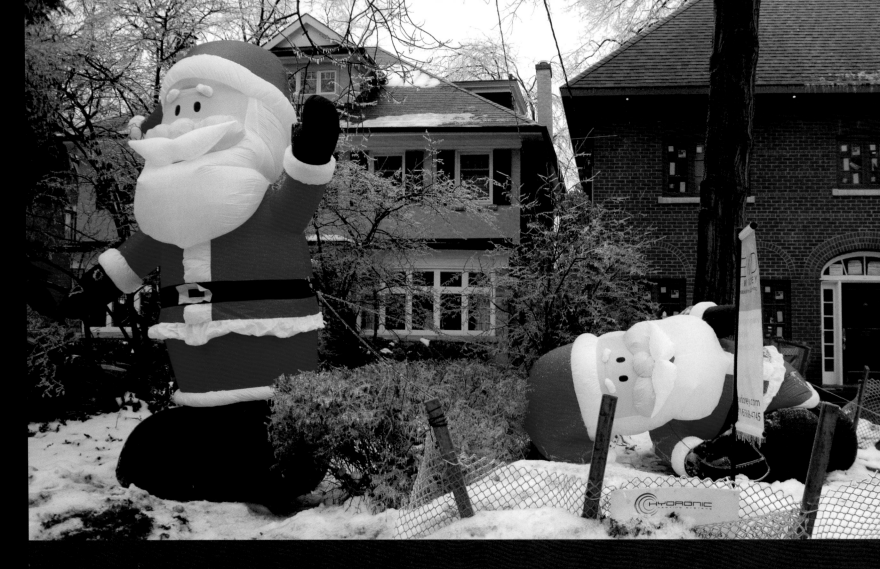

In the weeks before Christmas, more than two dozen giant, inflatable Santas were installed along Inglewood Drive in Toronto's Moore Park area, creating an instant attraction for neighbours and people driving by. Sadly, many of the outsize Saint Nicks were deflated or knocked over by the loss of power and the weight of the ice. A few, however, continued to stand tall.

"Our street lost power from Sunday to Friday. Our Christmas was a little brighter when our neighbour lit up his Christmas tree with a generator," writes Andra Stancu.

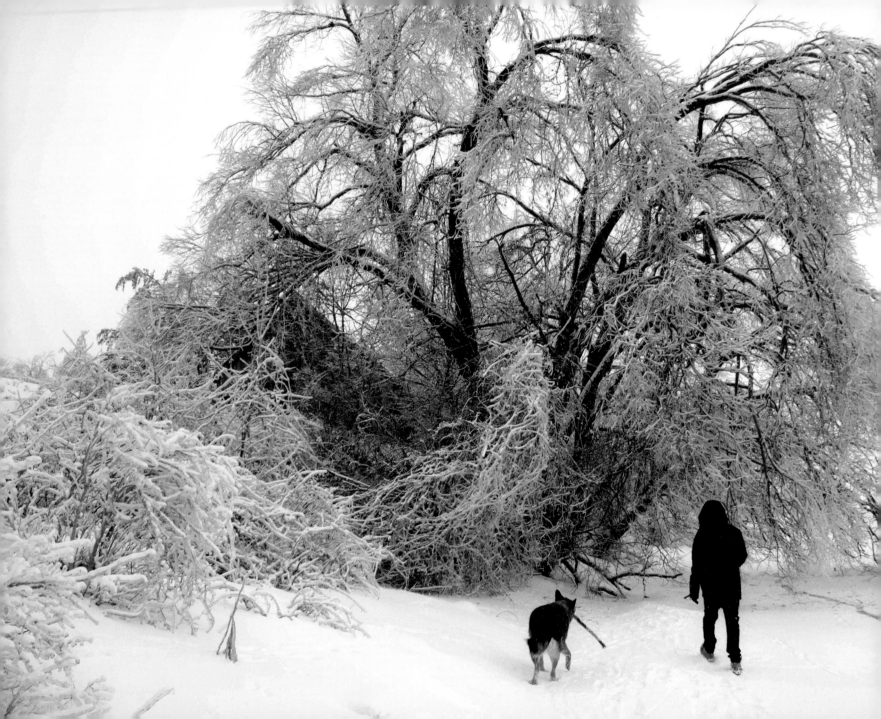

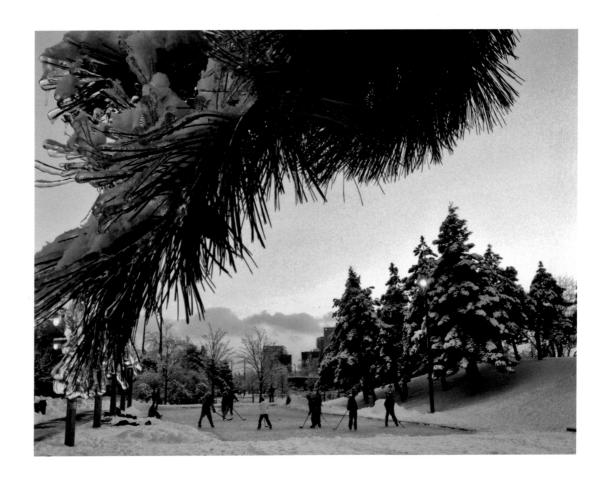

LEFT: On a Christmas Day without power, James Hogg walks his dog, Gracie, along the shore of Picton Bay in Prince Edward County. ABOVE: After five days without electricity, a group of friends in North York decide to stay warm and pass the time with a little shinny.

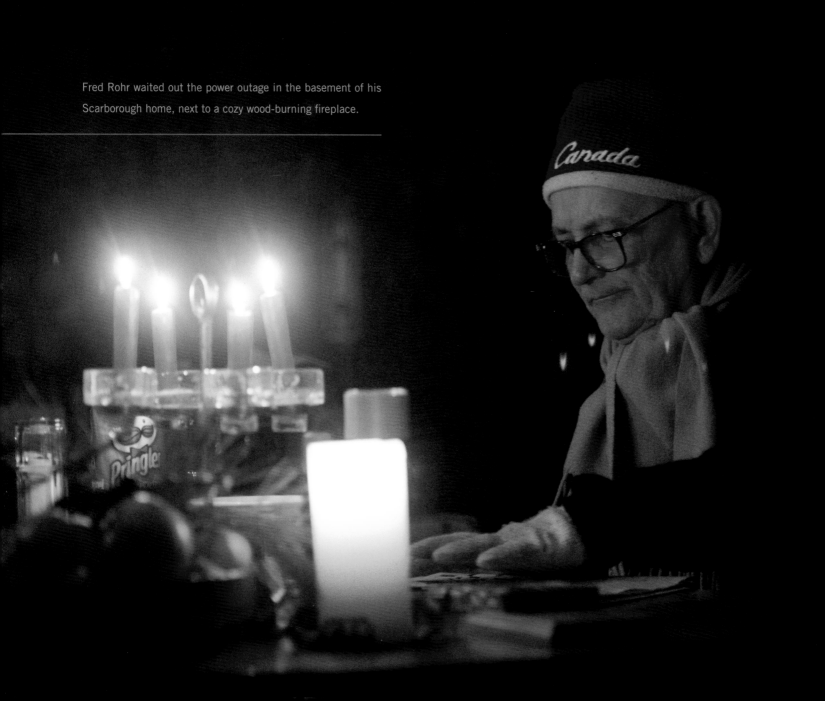

Fred Rohr waited out the power outage in the basement of his Scarborough home, next to a cozy wood-burning fireplace.

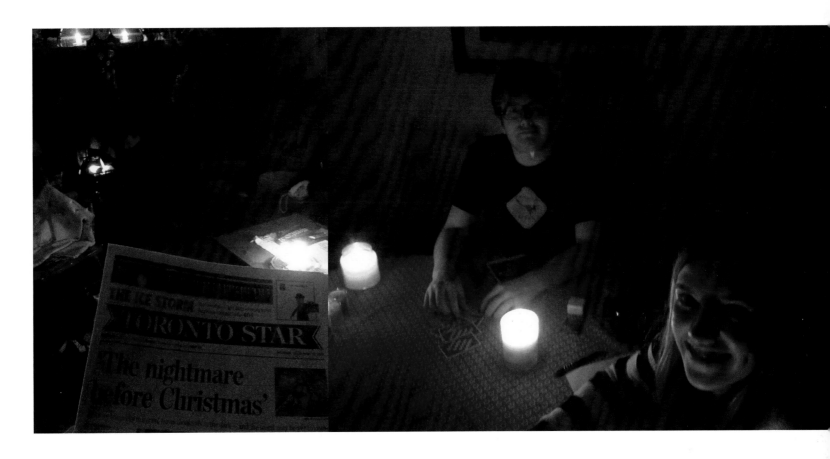

Not to be defeated by the storm, people found ways to entertain themselves as they waited for power to be restored. Here, Stephanie Bond and her parents catch up on the latest ice storm news while Glenn Cuthbertson's family plays cards by candlelight.

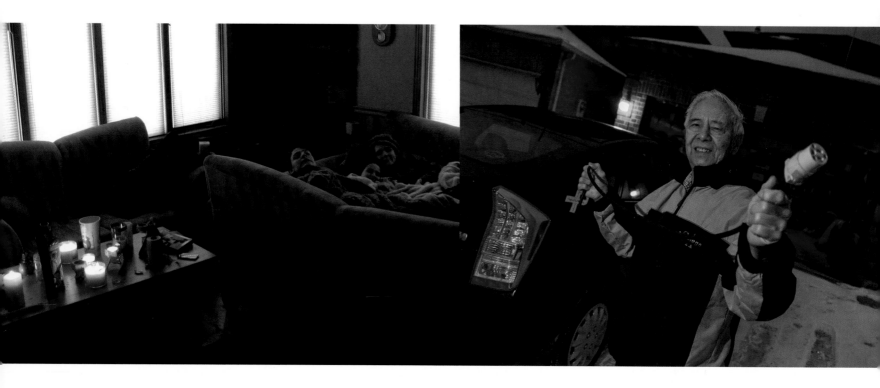

ABOVE LEFT: In Pickering, an area particularly hard hit with power outages, the Kalisch family snuggles together under blankets to stay warm. They had been kept awake all the previous night by branches crashing on their roof. ABOVE RIGHT: In Thornhill, retired Air Force mechanic Bob Osemlak got the bright idea to power his furnace, lights, refrigerator and TV by tapping the battery of his Toyota Prius. Other people's electricity hacks were more risky: emergency calls about non-fatal carbon monoxide poisonings from gas-powered generators were common during the outage.

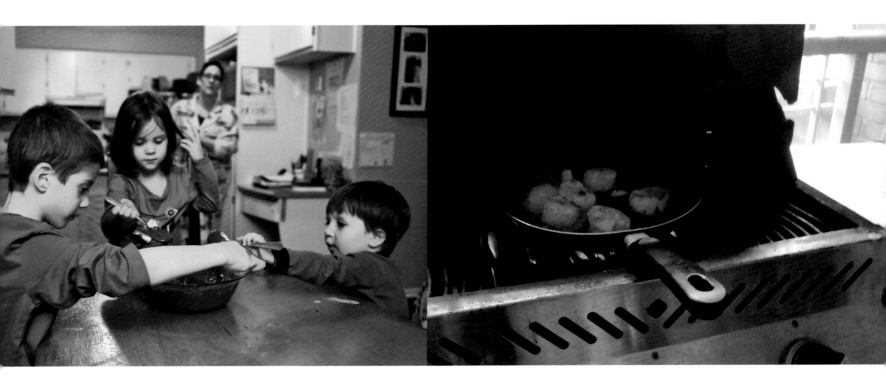

ABOVE LEFT: Ben Gaum's family were without power for four days and moved in with his sister in Thornhill. The children whipped up chocolate cake to keep busy. Many families were forced to camp out at the homes of relatives and in-laws who still had power. ABOVE RIGHT: With thousands of stoves out of commission, barbecues were put on active duty, like this one, in north Toronto, roasting up a pan full of scallops.

ABOVE LEFT: Richard Hutchison and his son Andrew are back to check on their home on Christmas Day. Like so many, they could not stay in their house and had to find alternate accommodation. ABOVE RIGHT: Baghda Yagowb and Jennie McNeil stay warm in a generator-powered community room on the main floor of their building.

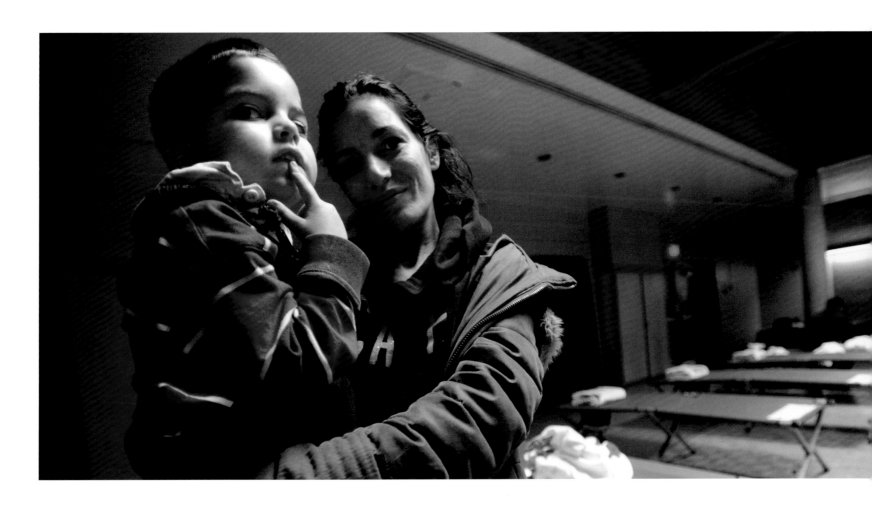

In Toronto, the city turned many community centres into warming centres for people caught without power. Here, Lina Sanfracesco and her son, Noah, who suffers from asthma, take shelter in the Malvern Community Centre in Scarborough.

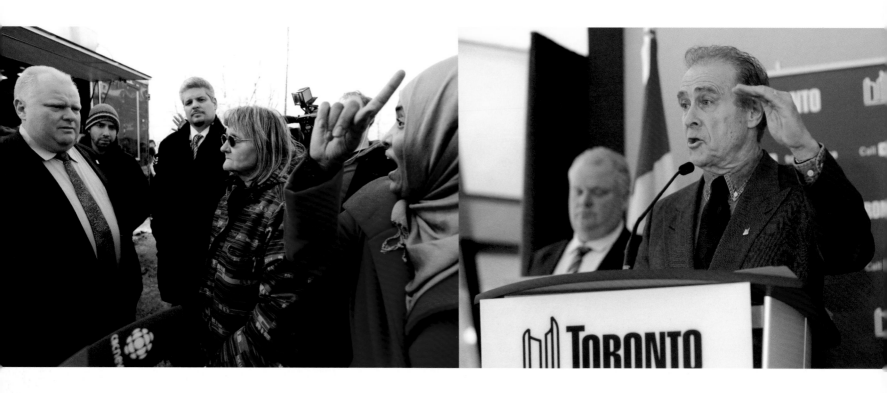

ABOVE LEFT: Mayor Rob Ford gets an earful for not declaring the storm an emergency from some residents of a Scarborough apartment complex that had been without power for nearly a week. ABOVE RIGHT: Toronto Deputy Mayor Norm Kelly, flanked by Mayor Rob Ford, addresses the media shortly after New Year's Day. While some political leaders and government representatives stayed on top of developments in the storm clean-up and informed people as best they could, others were missing in action.

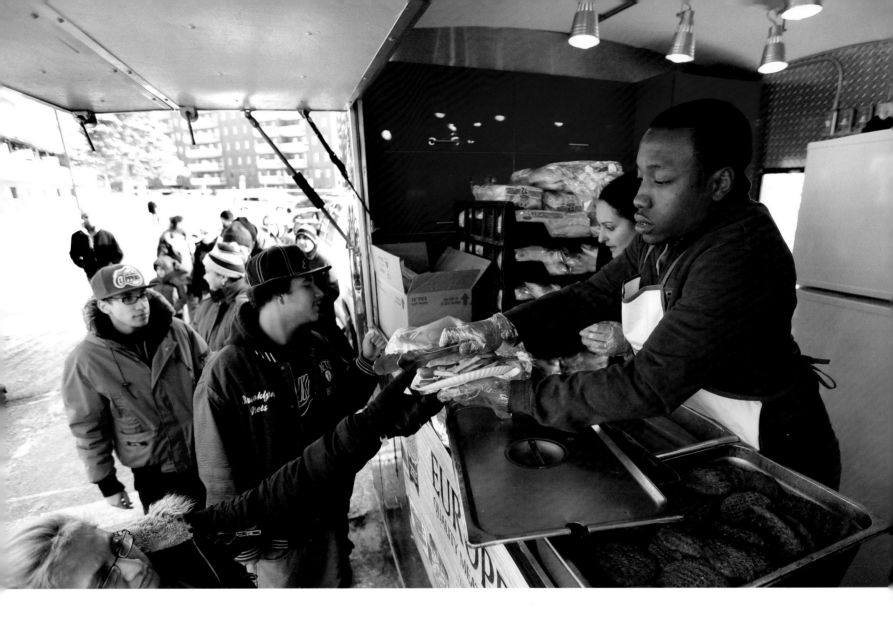

Residents of a Scarborough apartment building without power line up
for hamburgers, hot dogs and hot chocolate.

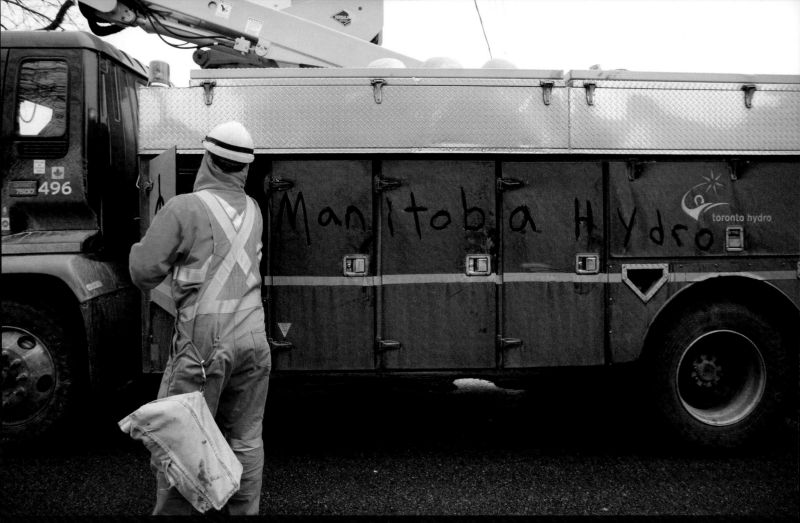

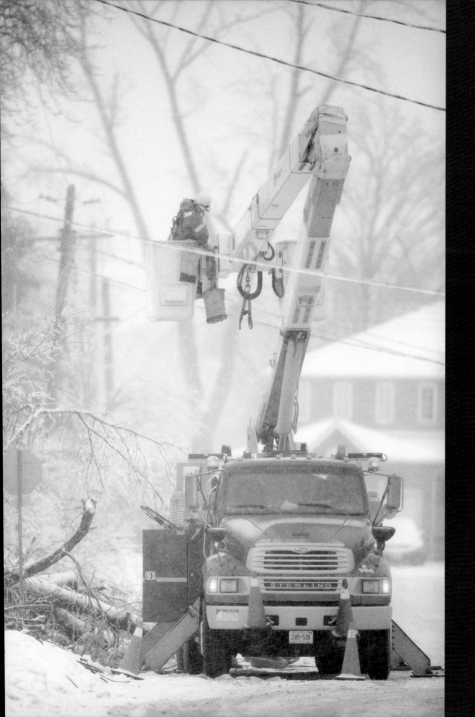

Two hundred bucket trucks spent weeks driving around the GTA replacing lines and powering up neighbourhoods. Hydro workers from across the province and from as far away as Manitoba volunteered to give up their holidays to work brutally long days to get people back on the grid. They were the heroes of the storm.

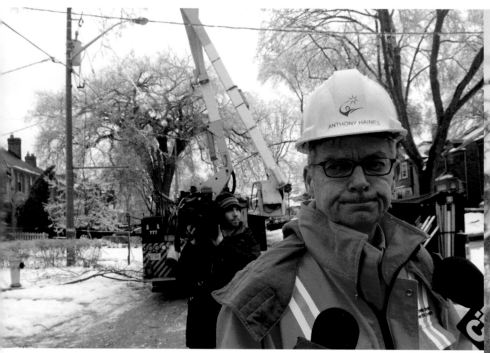

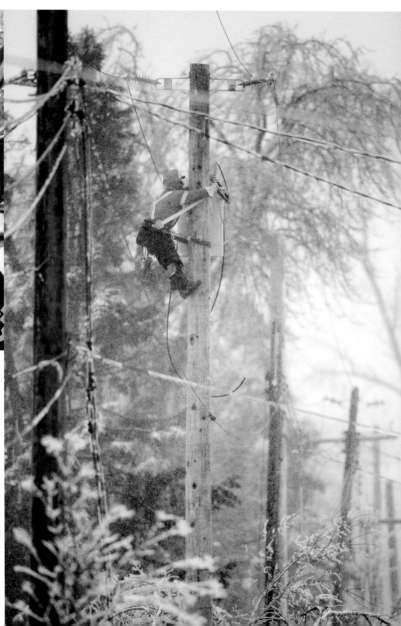

ABOVE: Toronto Hydro CEO Anthony Haines was everywhere — visiting the crews and checking on the progress of restoring power to individual homes, which he compared to "hand-to-hand combat."
RIGHT: Many hydro workers, like Ben Brown of Sault Ste. Marie, were forced to don old-school boot spikes in order to shimmy up utility poles with damaged lines and transformers.

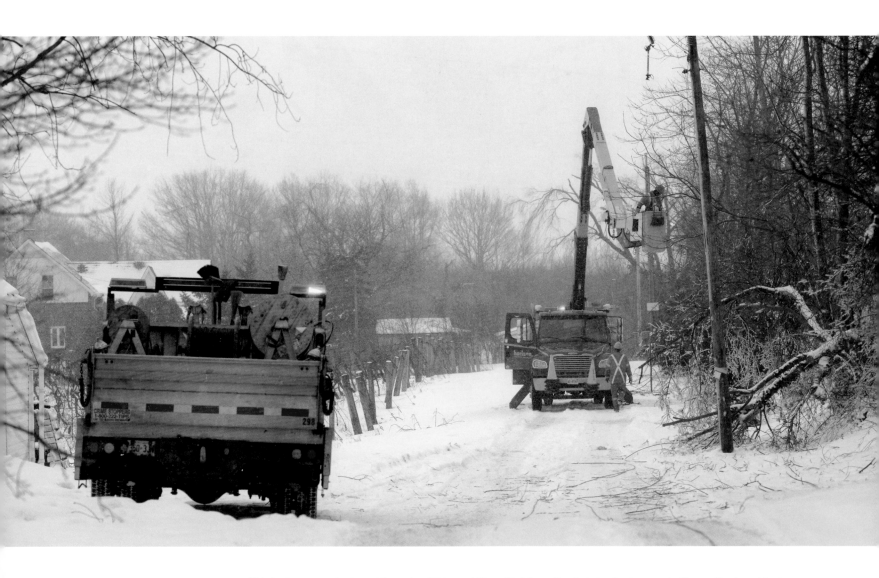

This hydro crew volunteered to work a 16-hour shift on Christmas Day to bring back power to Stoney Creek residents.

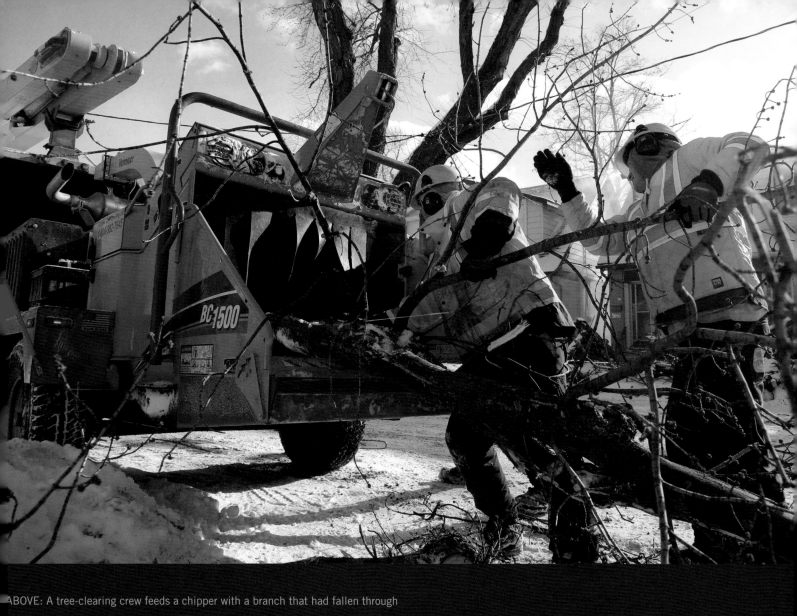

ABOVE: A tree-clearing crew feeds a chipper with a branch that had fallen through the roof of an East York home. RIGHT: City of Toronto workers perform the messy business of clearing broken tree limbs near Danforth and Coxwell avenues.

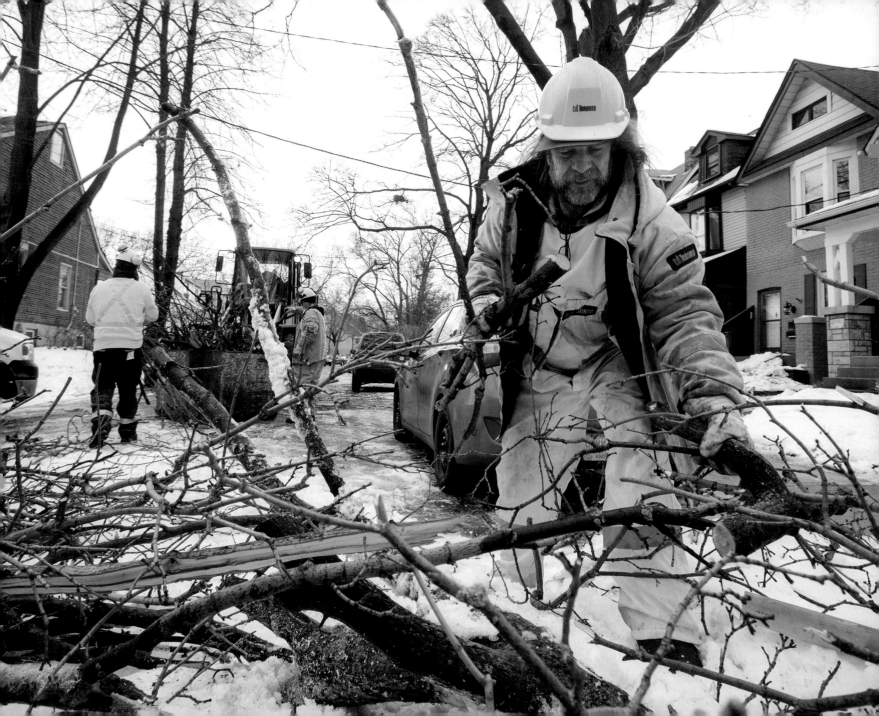

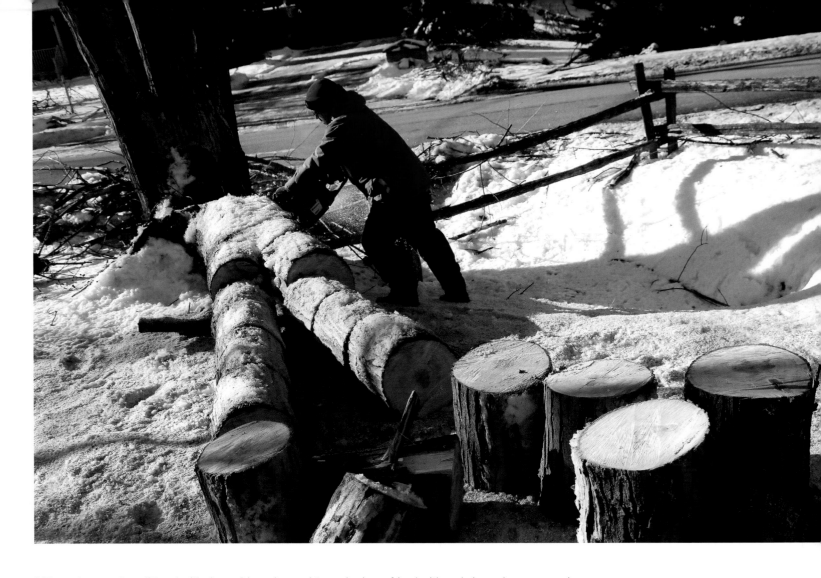

With yards everywhere littered with downed branches and trees, having a friend with a chainsaw became a real advantage. Here, Bill Land cuts up a tree for his neighbour in the Highland Creek area, while on Mount Pleasant Road Graham Hallward and Mark Hopson cut branches with a handsaw and a chainsaw.

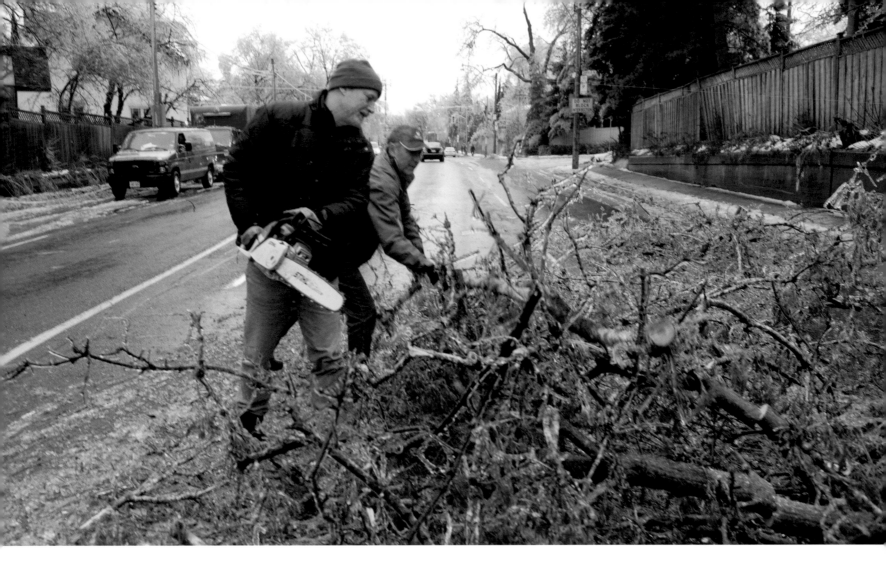

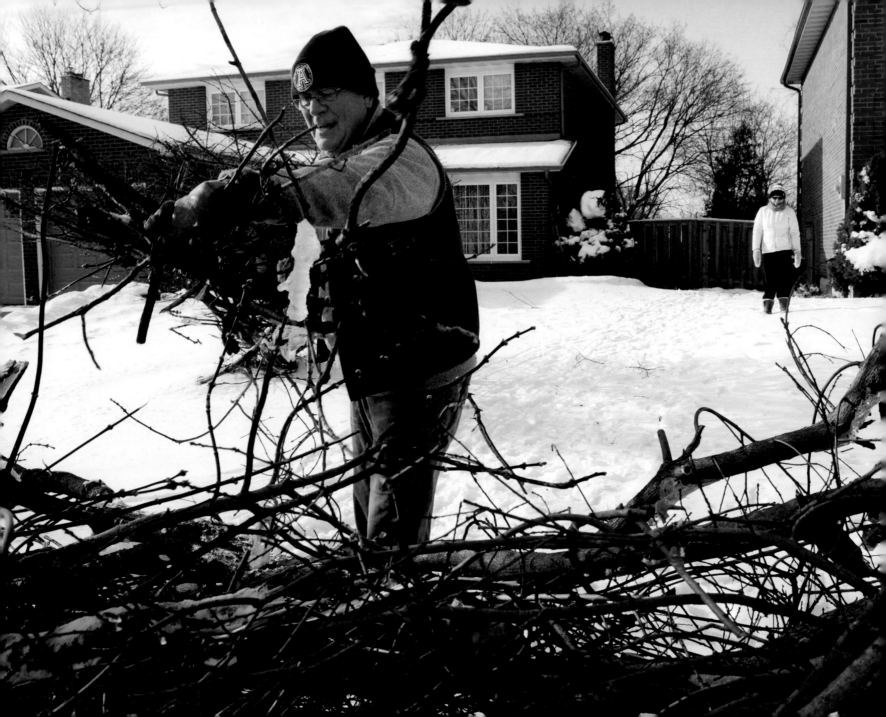

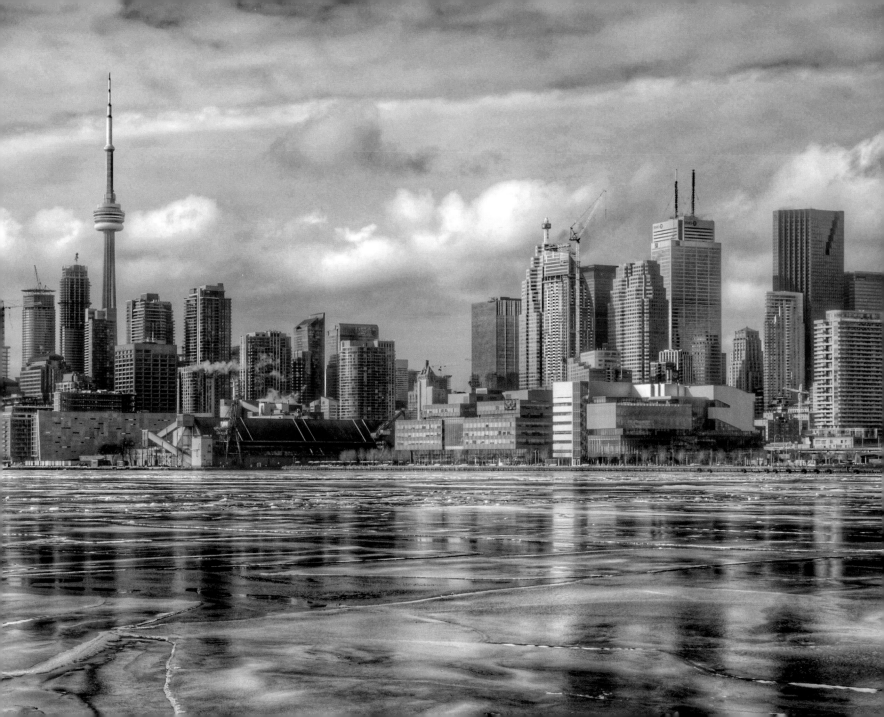

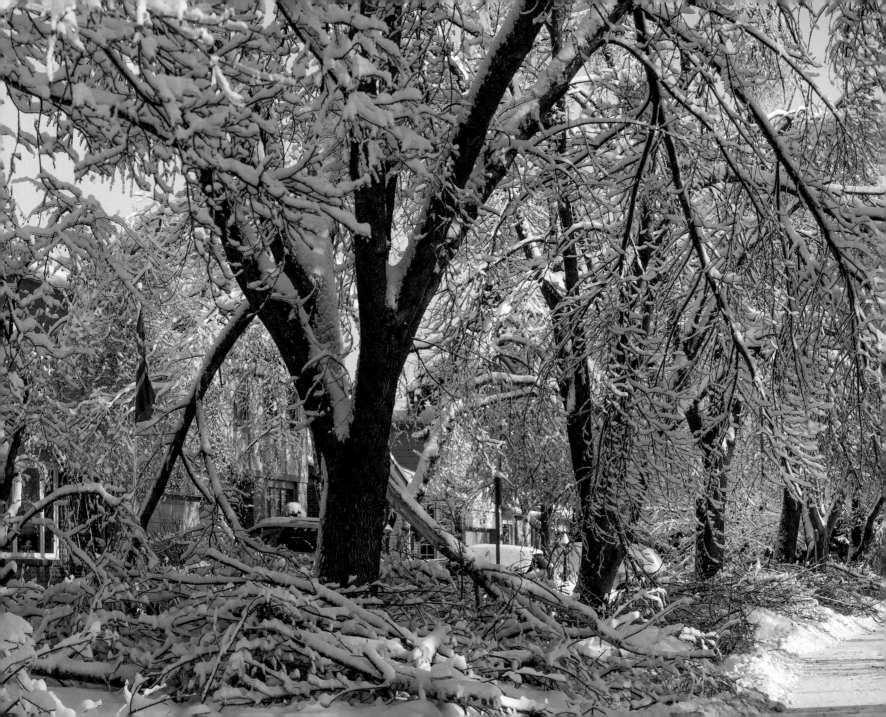

The ice storm was the furthest thing from a short, sharp shock. Even as power was slowly getting restored and the broken trees were getting cleared away, Nature made clear she had more in store. Shortly after New Year's Day, a bitter cold front created by the destabilization of the polar vortex (a kind of permanent, swirling cyclone of frigid air that normally stays close to the Arctic Circle) swooped down through Canada and the United States. The front dumped snow as it went and forced temperatures to record or near-record lows. Many southern Ontario residents were soon acquainted with another odd cold weather phenomenon: cryoseisms, or "frost quakes," which occur when moisture trapped in the ground (after, say, a bout of freezing rain) suddenly freezes up and expands, creating an ominous, booming sound, loud enough to wake people out of a deep sleep. The nasty cold and the snow also meant continuing chaos at airports, with many flights grounded or delayed, stranding passengers. Toronto's Pearson Airport shut down entirely for more than eight hours when the temperatures hit -40 degrees with the wind chill. Even the de-icing fluid stops doing its job at that temperature. The weeks after the storm also revealed just how severe an impact it had on the region's trees: Toronto lost an enormous chunk of its tree canopy, an event that Brian Mercer, one of the city's forestry supervisors, called "the worst I've ever seen." And even as Valentine's Day decorations began to appear in the stores, some people were still without power.

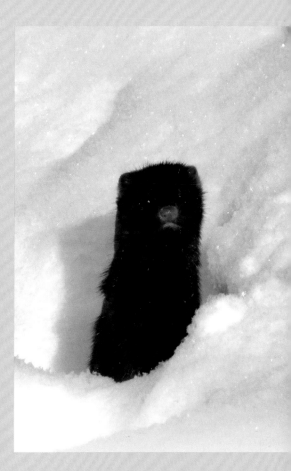

LEFT: Snow softens the extensive damage suffered on this Thornhill street. RIGHT: A wild mink pops out of a deep snow drift near Oakville. After the ice storm, temperatures dropped and deep snow fell.

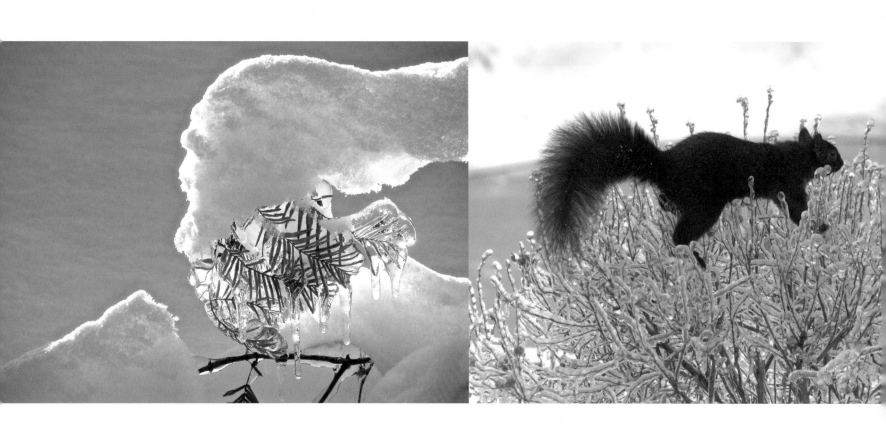

ABOVE LEFT: A healthy dollop of snow rests on a bush still gripped by ice remnants. ABOVE RIGHT: A squirrel steps gingerly across the top of a frozen bush. RIGHT: A wet fox scrambles over the ice on the Lake Ontario shoreline.

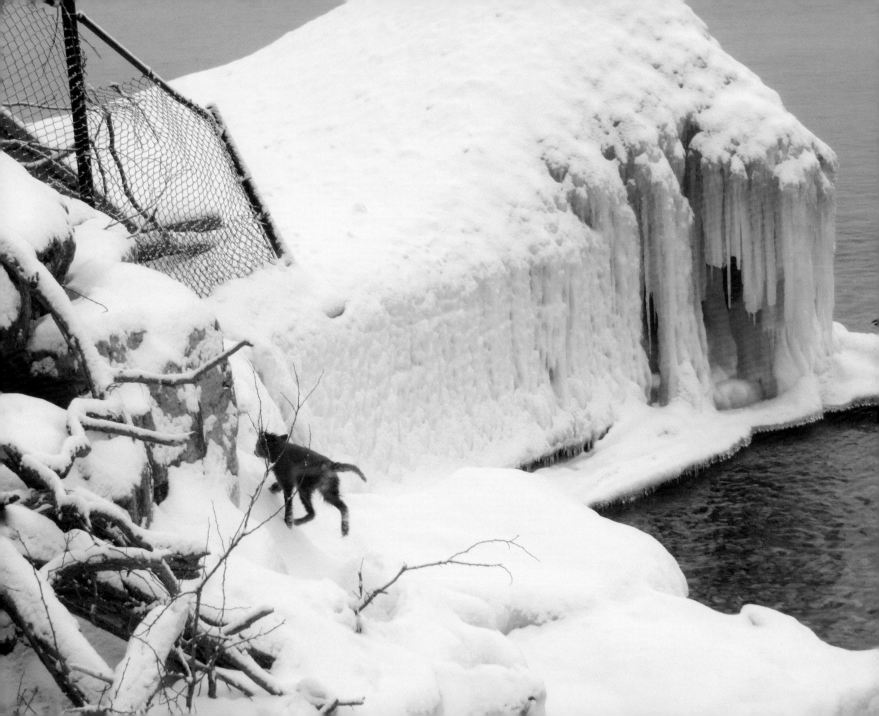

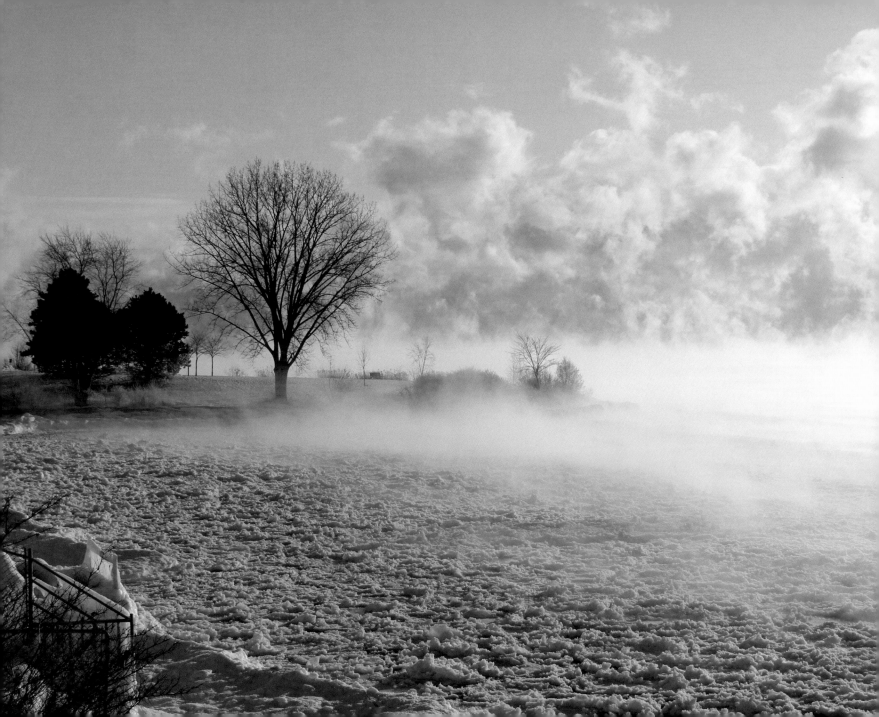

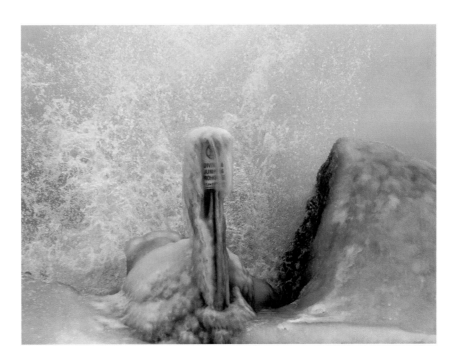

LEFT: Drifting clouds of cold-weather fog near the lakeshore in Toronto's west end during the post–ice storm deep freeze. ABOVE: The ice accumulating during the deep freeze threatens to engulf a superfluous No Diving sign at Cobourg Harbour.

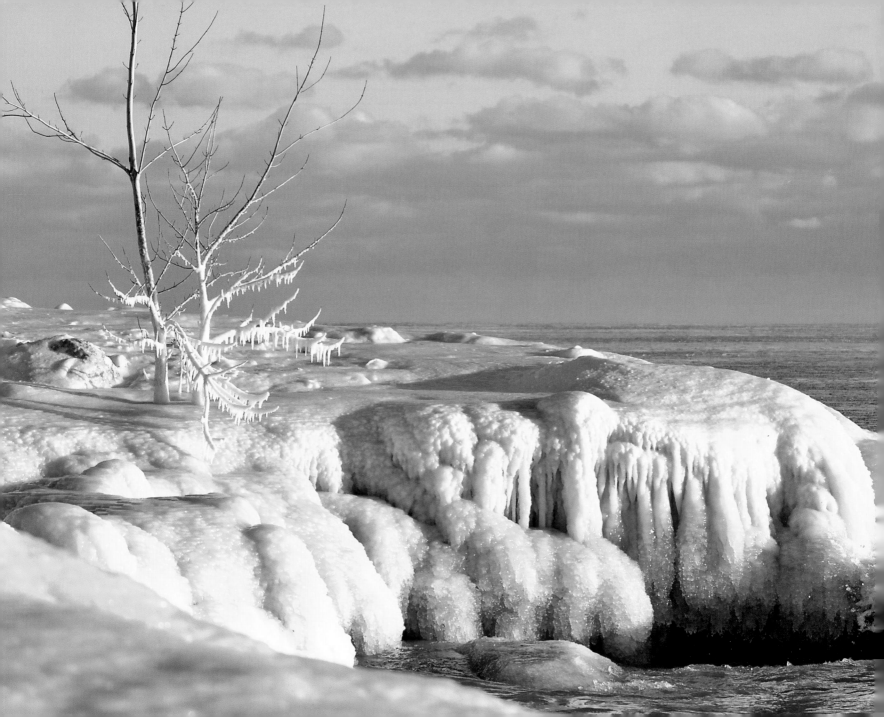

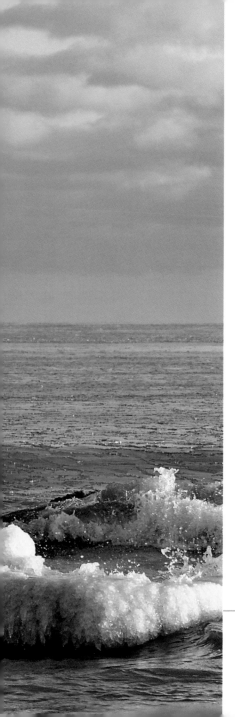

Toronto's Kew Beach, transformed by its thick coating
of ice, looks like a landscape from a fantasy novel.

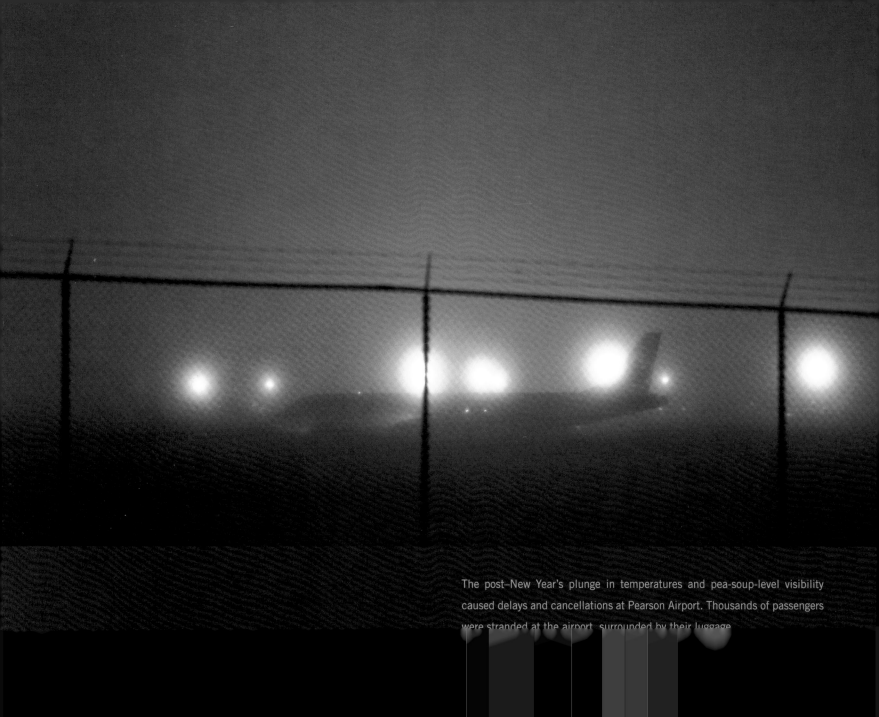

The post–New Year's plunge in temperatures and pea-soup-level visibility caused delays and cancellations at Pearson Airport. Thousands of passengers were stranded at the airport, surrounded by their luggage.

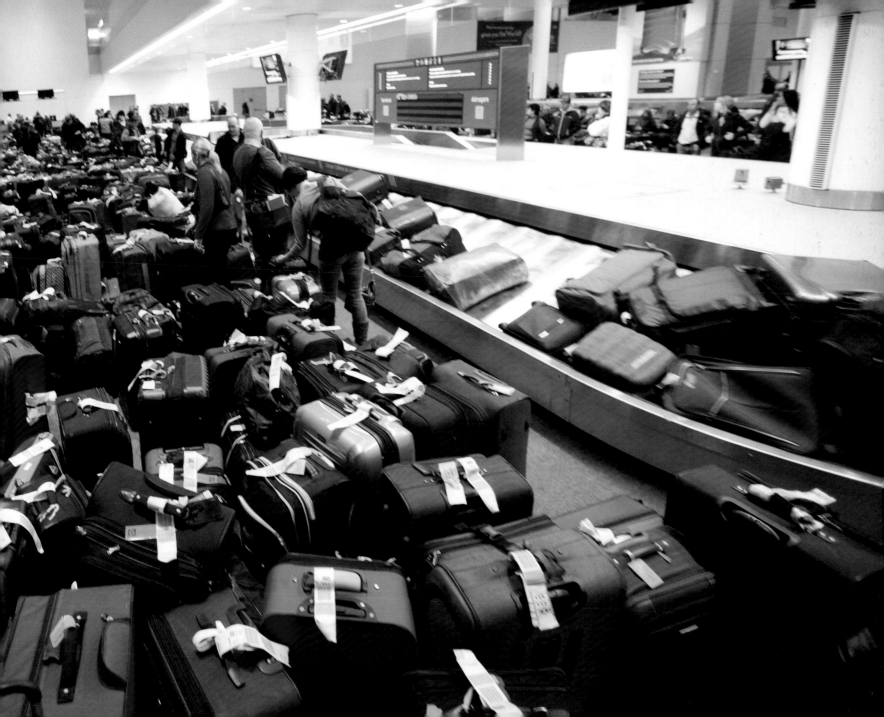

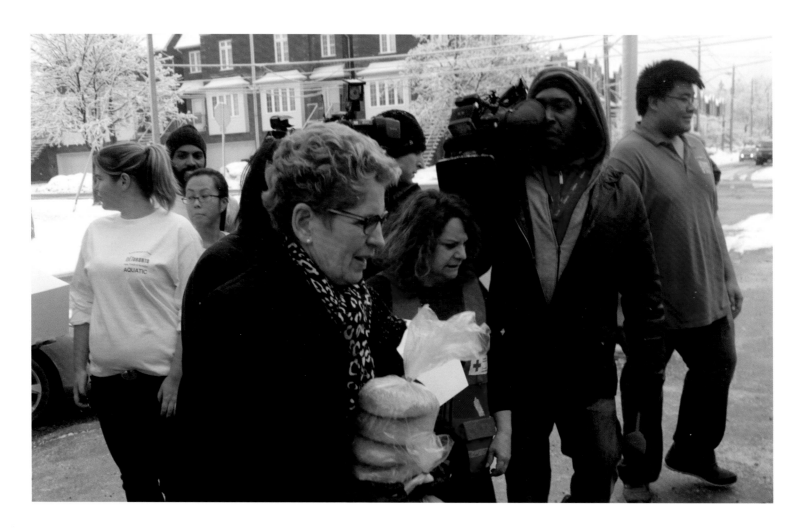

Premier Kathleen Wynne arrives at a Scarborough warming centre on Christmas Day with an armload of bagels. In the next week, Wynne would institute a food gift card program to compensate people whose food spoiled in the power outage.

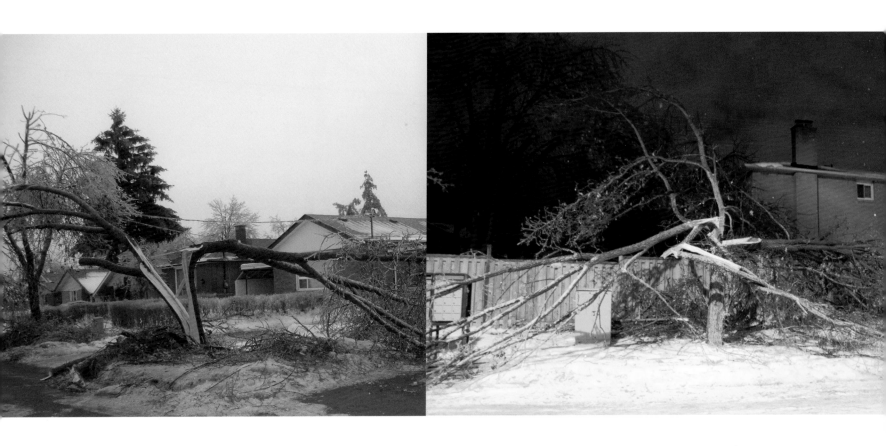

The total cost of the damage from the ice storm has been estimated at over $100 million for Toronto alone. While the price tag is breathtaking, just as alarming is the long-term effect it will have on the urban forest. As much as 20% of the city's trees may have been lost or severely damaged.

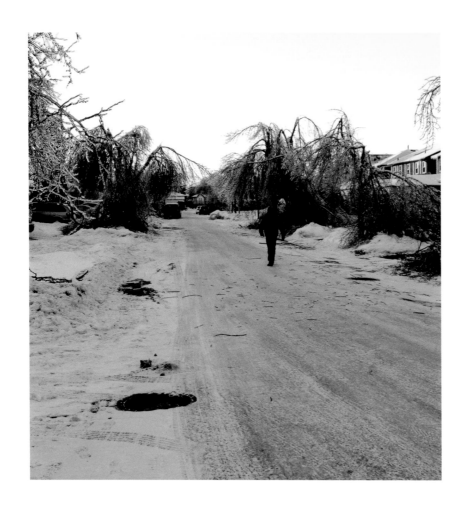

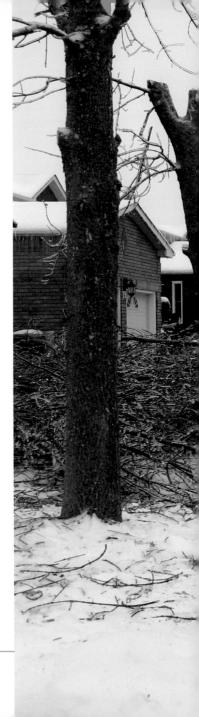

Every tree has been damaged on Newgreen Crescent in Brampton
and on Whitbread Avenue in Bolton. Streets across the GTA share
this devastation and it will be decades before the canopy recovers.

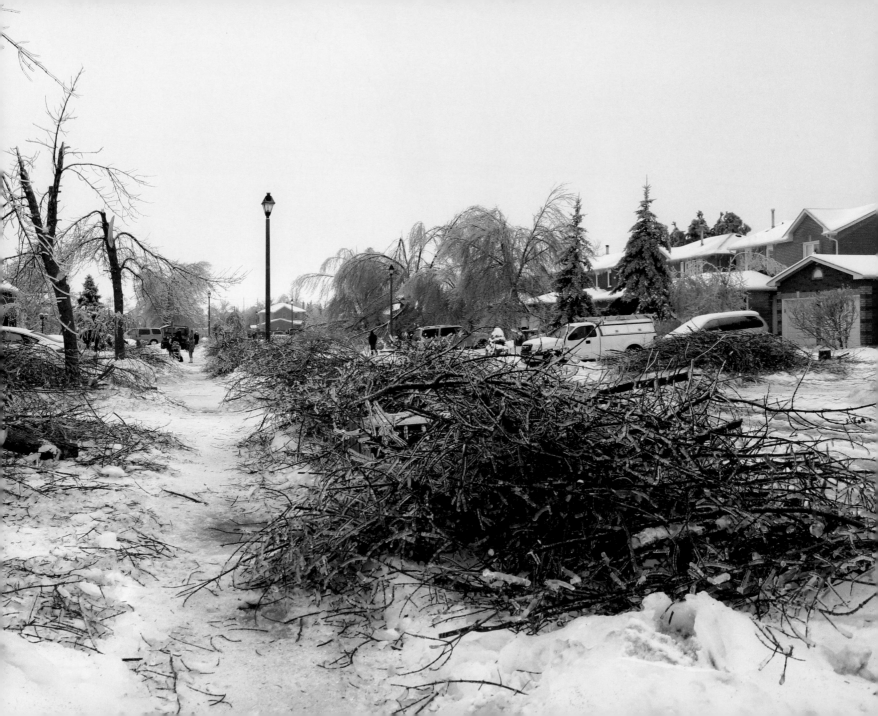

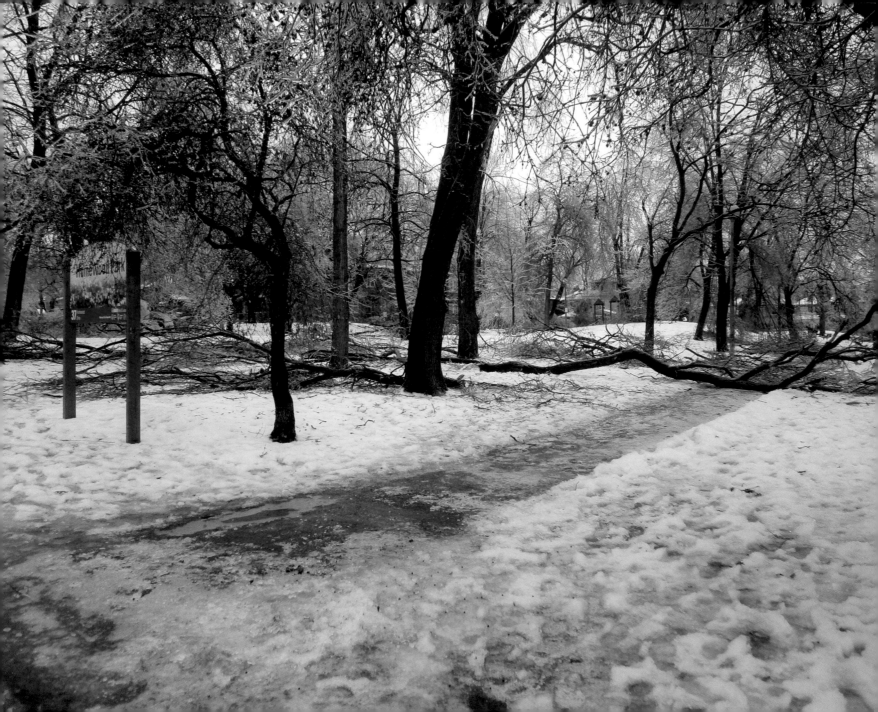

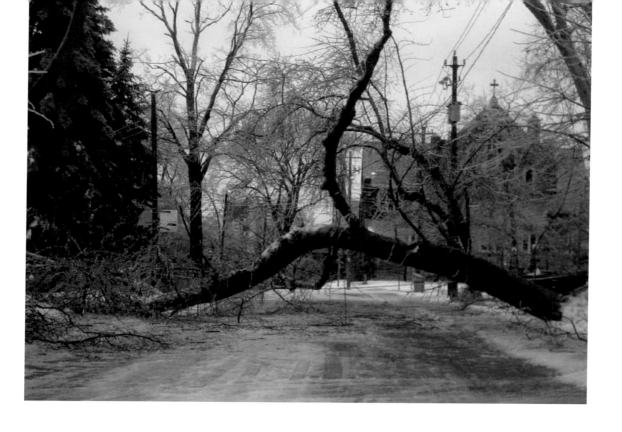

LEFT: Humewood Park, near St. Clair and Bathurst streets in Toronto, remained closed for weeks after the storm because of fallen tree limbs. ABOVE: A massive tree trunk lies across the street in front of Bishop Strachan School.

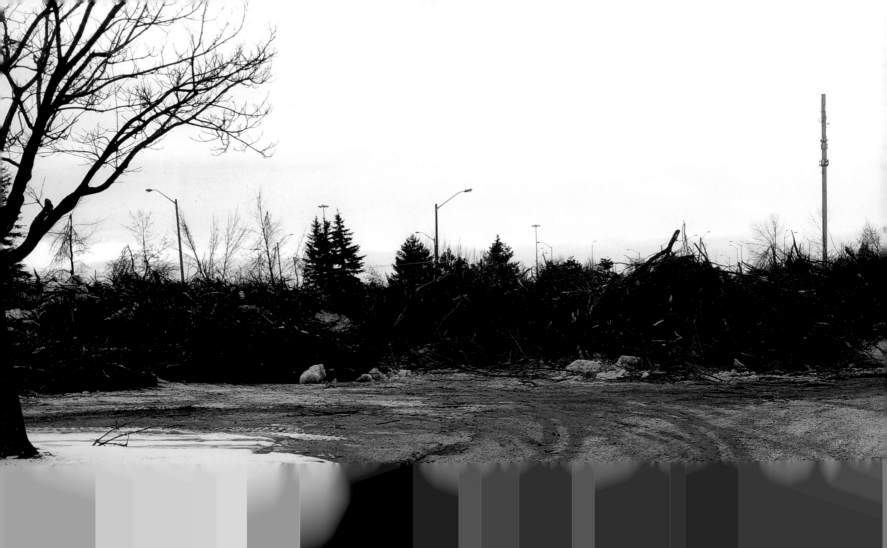

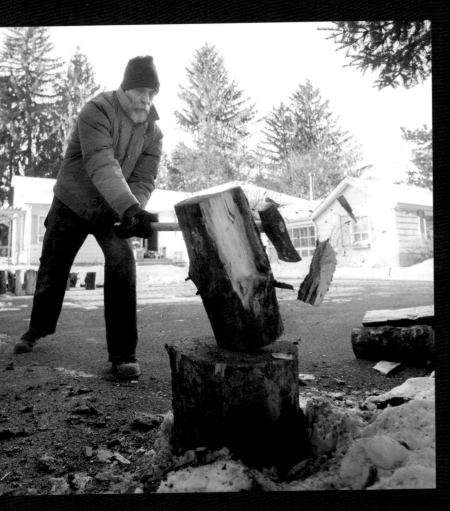

Mississauga's David Farmer may have been the last person without power in southern Ontario. A month after the storm, with out-of-town hydro crews already gone and the power back across the region, Farmer was still waiting for the juice to go back on at his home. He stayed warm by cutting wood on his property for his wood-burning stove. "When the machine stops, it's nice to know you can carry on," he says.

Photo Credits

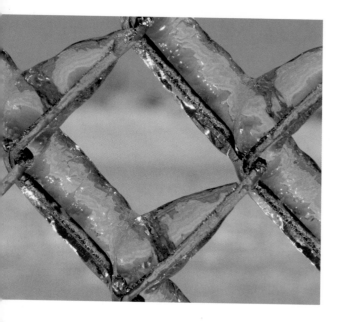

Hellen Alatzakis: 55 (left), 77

Armand Baksh-Zarate: 112

Anita Barber: 36, 104

Vida Barker: 69

Andy Basacchi: 66

Keith Beaty/Toronto Star: 20, 21, 74, 88 (left), 93

James D. Becksted: 115

Teri-Lyn Behuniak-Ball: 109 (right)

Mike Bell: 65, 118

Mark Berkovich: 73

Alyssa Black: 96

Stephanie Bond: 79 (left)

Betty Campitelli: 116

Megan Cooke: 67

Devin Cote: 19

Cathie Coward/Hamilton Spectator: 72, 89

Carolyn Craig: 25

Lieah Crust: 103

Stefanie Cuda: 7

Glenn Cuthbertson: 79 (right)

John Daruwala: 41 (right)

Linda Down: 40, 64 (right)

Karina Dywanski: 55 (right)

Barry Emerson: 24, 50, 68

Paolo Falzone: 48 (right)

Mike Foley: 102

Suzanne Gardner: 41 (left)

Ben Gaum: 57, 81 (left)

Molly Gillan: 59

Rico Giovannini: 113

June Gleed: 51

Tony Goldstein: 60

Jan Green: 100 (left), 119

Val Gunn: 109 (left)

Steve Harrington: 47, 61

Christine Hogg: 58, 76

Ed Horawski: 52

Gloria Hutchison: 82 (left)

Rene Johnston/Toronto Star: 23, 84 (right), 92, 110

Ken Kalisch: 48 (left), 80 (left)

Rachel Katz: 114

Winston King: 26

Oleksandra Korobova: 54

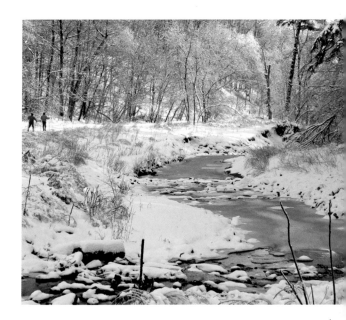

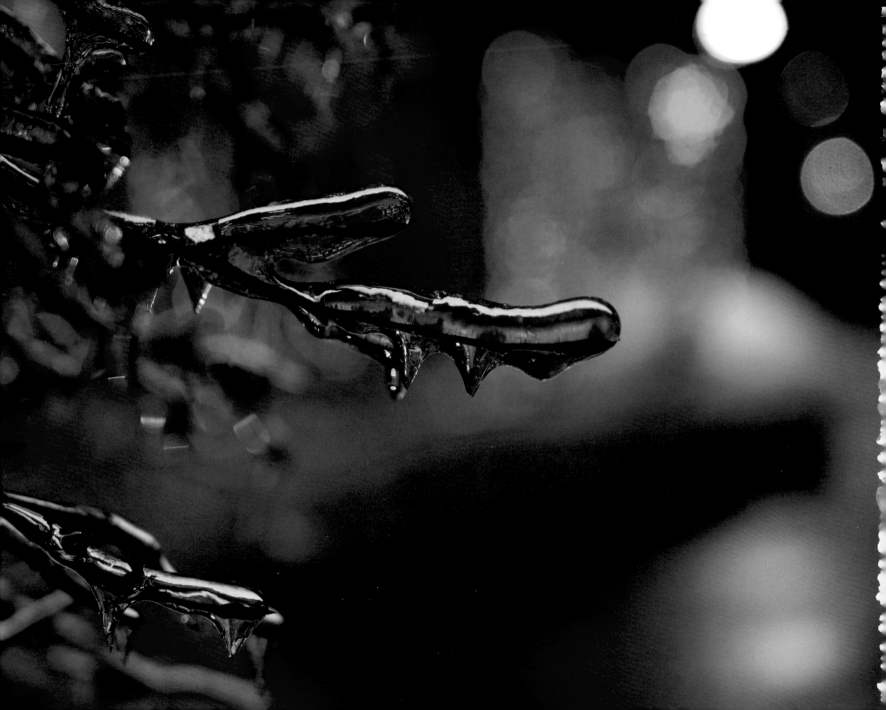